NAME: _____

ADDRESS: _____

_____

_____

_____

# KILN SECTION

# CONE CHART

## CONE CHART EQUIVALENTS

| CONE | F | C |
|------|------|------|
| 10 | 2381 | 1305 |
| 9 | 2336 | 1280 |
| 8 | 2320 | 1271 |
| 7 | 2295 | 1257 |
| 6 | 2269 | 1243 |
| 5 | 2250 | 1207 |
| 4 | 2161 | 1183 |
| 3 | 2138 | 1170 |
| 2 | 2127 | 1164 |
| 1 | 2109 | 1154 |
| 01 | 2080 | 1138 |
| 02 | 2052 | 1122 |
| 03 | 2019 | 1104 |
| 04 | 1971 | 1077 |
| 05 | 1911 | 1044 |
| 06 | 1855 | 1013 |
| 07 | 1809 | 987 |
| 08 | 1753 | 956 |
| 09 | 1706 | 930 |
| 010 | 1679 | 915 |
| 011 | 1641 | 894 |
| 012 | 1620 | 882 |
| 013 | 1582 | 861 |
| 014 | 1540 | 838 |
| 015 | 1501 | 818 |
| 016 | 1465 | 796 |
| 017 | 1404 | 763 |
| 018 | 1353 | 734 |
| 019 | 1283 | 695 |
| 020 | 1180 | 638 |
| 021 | 1143 | 617 |
| 022 | 1094 | 590 |

HIGH FIRE STONEWARE AND PORCELAIN CLAY BODIES AND GLAZES MATURE

MIDRANGE STONEWARE AND PORCELAIN CLAY BODIES AND GLAZES MATURE

WEAR PROTECTIVE EYEWARE ABOVE 2000 F

BISQUE TEMP FOR STONEWARE/PORCELAIN

OVERGLAZES AND LUSTERS

ALL CONES MATURE WITH TIME AND TEMPERATURE.

ALL TEMPERATURE EQUIVALENTS ON THIS CHART ARE BASED ON A 270° F (150° C) PER HOUR RATE CLIMB USING THE LARGE SELF SUPPORTING CONE. RATES OF CLIMB CHANGE PER FIRING AS DO TEMPERATURE EQUIVALENTS.

IT IS IMPORTANT TO DIFFERENTIATE BETWEEN CONE 06-04 AND CONE 4-6.

CONE IS OFTEN REPLACED WITH THIS SYMBOL $\Delta$

# CONE PACKS

It takes three cones to make a cone pack:

The warning cone, the target cone, and the guard cone. The warning cone lets you know when you are approaching maturity, the target cone lets you know when you have reached the target temperature, and the guard cone is one cone above the target cone.

In a low temp firing, you will need a low fire cone pack. For example, cone 07, cone 06, and cone 05.
In a mid range glaze firing, you will need a mid range cone pack. For example, cone 5, cone 6, and cone 7.
In a high fire glaze firing, you will need a high fire cone pack. For example, cone 9, cone 10, and cone 11.

If you are using the self-supporting cones, place them on a kiln-washed tray or cookie for easy removal.
Place one cone pack per level, in view of the peep holes, *Wear eye protection when looking in the kiln.*

---

### WADDING RECIPE

| | |
|---|---|
| KAOLIN -------------- | 50% |
| ALUMINA HYDRATE | 50% |
| ------ | ----- |
| TOTAL --------------- | 100% |

Add water until workable clay consistency. There are many different wadding recipes. Organics like coffee grounds and sawdust should not be used in electric firings because the organics will burn off and shorten the lives of the elements.

---

### KILN WASH RECIPE

| | |
|---|---|
| KAOLIN -------------- | 40% |
| ALUMINA HYDRATE | 40% |
| SILICA --------------- | 20% |
| -------- | ----- |
| TOTAL --------------- | 100% |

Mixed to whole milk consistency. You can sub 50% of the kaolin for calcined kaolin if the kiln wash is flaking.

---

### HOW TO MAKE A CONE PACK

1. Make your cone pack on a piece of newspaper, so the clay/wadding doesn't stick. Roll your coil 1/2in thick, and flatten to 3/8in thick.
2. Hold the base of the cone against a flat surface, note the back (the face with the cone imprint) and note the angle of the cone.
3. Press the cone in as far as it will go, making sure it is sitting at the correct angle or slightly more.
4. The lowest cone should be positioned on the end so it falls first without touching the higher cone .
5. Trim off excess clay/wadding.

WARNING CONE · TARGET CONE · GUARD CONE

KILN LOG DATES _____

| FIRING # | DATE | FIRING TYPE | TARGET TEMP | START TEMP | START TI |
|---|---|---|---|---|---|
| | | | | | |
| | | | | | |
| | | | | | |
| | | | | | |
| | | | | | |
| | | | | | |
| | | | | | |
| | | | | | |
| | | | | | |
| | | | | | |
| | | | | | |
| | | | | | |
| | | | | | |
| | | | | | |
| | | | | | |
| | | | | | |
| | | | | | |
| | | | | | |
| | | | | | |
| | | | | | |
| | | | | | |
| | | | | | |
| | | | | | |
| | | | | | |
| | | | | | |
| | | | | | |
| | | | | | |
| | | | | | |
| | | | | | |
| | | | | | |
| | | | | | |
| | | | | | |
| | | | | | |
| | | | | | |
| | | | | | |

| ND TIME | TOTAL TIME | COOL TIME | KWH USE | COST |
|---|---|---|---|---|
|  |  |  |  |  |
|  |  |  |  |  |
|  |  |  |  |  |
|  |  |  |  |  |
|  |  |  |  |  |
|  |  |  |  |  |
|  |  |  |  |  |
|  |  |  |  |  |
|  |  |  |  |  |
|  |  |  |  |  |
|  |  |  |  |  |
|  |  |  |  |  |
|  |  |  |  |  |
|  |  |  |  |  |
|  |  |  |  |  |
|  |  |  |  |  |
|  |  |  |  |  |
|  |  |  |  |  |
|  |  |  |  |  |
|  |  |  |  |  |
|  |  |  |  |  |
|  |  |  |  |  |
|  |  |  |  |  |
|  |  |  |  |  |
|  |  |  |  |  |
|  |  |  |  |  |
|  |  |  |  |  |
|  |  |  |  |  |
|  |  |  |  |  |
|  |  |  |  |  |
|  |  |  |  |  |
|  |  |  |  |  |
|  |  |  |  |  |
|  |  |  |  |  |
|  |  |  |  |  |
|  |  |  |  |  |
|  |  |  |  |  |

KILN LOG DATES _____

| FIRING # | DATE | FIRING TYPE | TARGET TEMP | START TEMP | START TI |
|----------|------|-------------|-------------|------------|----------|
|  |  |  |  |  |  |
|  |  |  |  |  |  |
|  |  |  |  |  |  |
|  |  |  |  |  |  |
|  |  |  |  |  |  |
|  |  |  |  |  |  |
|  |  |  |  |  |  |
|  |  |  |  |  |  |
|  |  |  |  |  |  |
|  |  |  |  |  |  |
|  |  |  |  |  |  |
|  |  |  |  |  |  |
|  |  |  |  |  |  |
|  |  |  |  |  |  |
|  |  |  |  |  |  |
|  |  |  |  |  |  |
|  |  |  |  |  |  |
|  |  |  |  |  |  |
|  |  |  |  |  |  |
|  |  |  |  |  |  |
|  |  |  |  |  |  |
|  |  |  |  |  |  |
|  |  |  |  |  |  |
|  |  |  |  |  |  |
|  |  |  |  |  |  |
|  |  |  |  |  |  |
|  |  |  |  |  |  |
|  |  |  |  |  |  |
|  |  |  |  |  |  |
|  |  |  |  |  |  |
|  |  |  |  |  |  |
|  |  |  |  |  |  |
|  |  |  |  |  |  |

KILN LOG DATES

| ND TIME | TOTAL TIME | COOL TIME | KWH USE | COST |
|---|---|---|---|---|
|  |  |  |  |  |
|  |  |  |  |  |
|  |  |  |  |  |
|  |  |  |  |  |
|  |  |  |  |  |
|  |  |  |  |  |
|  |  |  |  |  |
|  |  |  |  |  |
|  |  |  |  |  |
|  |  |  |  |  |
|  |  |  |  |  |
|  |  |  |  |  |
|  |  |  |  |  |
|  |  |  |  |  |
|  |  |  |  |  |
|  |  |  |  |  |
|  |  |  |  |  |
|  |  |  |  |  |
|  |  |  |  |  |
|  |  |  |  |  |
|  |  |  |  |  |
|  |  |  |  |  |
|  |  |  |  |  |
|  |  |  |  |  |
|  |  |  |  |  |
|  |  |  |  |  |
|  |  |  |  |  |
|  |  |  |  |  |
|  |  |  |  |  |
|  |  |  |  |  |
|  |  |  |  |  |
|  |  |  |  |  |
|  |  |  |  |  |
|  |  |  |  |  |
|  |  |  |  |  |
|  |  |  |  |  |
|  |  |  |  |  |
|  |  |  |  |  |
|  |  |  |  |  |
|  |  |  |  |  |
|  |  |  |  |  |
|  |  |  |  |  |

KILN LOG DATES ——————————

| FIRING # | DATE | FIRING TYPE | TARGET TEMP | START TEMP | START TI |
|---|---|---|---|---|---|
| | | | | | |
| | | | | | |
| | | | | | |
| | | | | | |
| | | | | | |
| | | | | | |
| | | | | | |
| | | | | | |
| | | | | | |
| | | | | | |
| | | | | | |
| | | | | | |
| | | | | | |
| | | | | | |
| | | | | | |
| | | | | | |
| | | | | | |
| | | | | | |
| | | | | | |
| | | | | | |
| | | | | | |
| | | | | | |
| | | | | | |
| | | | | | |
| | | | | | |
| | | | | | |
| | | | | | |
| | | | | | |
| | | | | | |
| | | | | | |
| | | | | | |
| | | | | | |
| | | | | | |
| | | | | | |

| END TIME | TOTAL TIME | COOL TIME | KWH USE | COST |
|---|---|---|---|---|
|  |  |  |  |  |
|  |  |  |  |  |
|  |  |  |  |  |
|  |  |  |  |  |
|  |  |  |  |  |
|  |  |  |  |  |
|  |  |  |  |  |
|  |  |  |  |  |
|  |  |  |  |  |
|  |  |  |  |  |
|  |  |  |  |  |
|  |  |  |  |  |
|  |  |  |  |  |
|  |  |  |  |  |
|  |  |  |  |  |
|  |  |  |  |  |
|  |  |  |  |  |
|  |  |  |  |  |
|  |  |  |  |  |
|  |  |  |  |  |
|  |  |  |  |  |
|  |  |  |  |  |
|  |  |  |  |  |
|  |  |  |  |  |
|  |  |  |  |  |
|  |  |  |  |  |
|  |  |  |  |  |
|  |  |  |  |  |
|  |  |  |  |  |
|  |  |  |  |  |
|  |  |  |  |  |
|  |  |  |  |  |
|  |  |  |  |  |
|  |  |  |  |  |
|  |  |  |  |  |
|  |  |  |  |  |
|  |  |  |  |  |
|  |  |  |  |  |
|  |  |  |  |  |

# KILN INVENTORY

FIRING #:           TYPE:

DATE:        CONE:      START TIME:

| OBJECT | QUANTITY |
|---|---|
|  |  |
|  |  |
|  |  |
|  |  |
|  |  |
|  |  |
|  |  |
|  |  |
|  |  |
|  |  |
|  |  |
|  |  |
|  |  |
|  |  |
|  |  |
|  |  |
|  |  |
|  |  |
|  |  |
|  |  |
|  |  |

NOTES:

FIRING #:           TYPE:

DATE:        CONE:      START TIME:

| OBJECT | QUANTITY |
|---|---|
|  |  |
|  |  |
|  |  |
|  |  |
|  |  |
|  |  |
|  |  |
|  |  |
|  |  |
|  |  |
|  |  |
|  |  |
|  |  |
|  |  |
|  |  |
|  |  |
|  |  |
|  |  |
|  |  |
|  |  |
|  |  |

NOTES:

FIRING #:    TYPE:

DATE:  CONE:  START TIME:

| OBJECT | QUANTITY |
|--------|----------|
|  |  |
|  |  |
|  |  |
|  |  |
|  |  |
|  |  |
|  |  |
|  |  |
|  |  |
|  |  |
|  |  |
|  |  |
|  |  |
|  |  |
|  |  |
|  |  |
|  |  |
|  |  |
|  |  |
|  |  |
|  |  |
|  |  |
|  |  |
|  |  |

NOTES:

FIRING #:    TYPE:

DATE:  CONE:  START TIME:

| OBJECT | QUANTITY |
|--------|----------|
|  |  |
|  |  |
|  |  |
|  |  |
|  |  |
|  |  |
|  |  |
|  |  |
|  |  |
|  |  |
|  |  |
|  |  |
|  |  |
|  |  |
|  |  |
|  |  |
|  |  |
|  |  |
|  |  |
|  |  |
|  |  |
|  |  |
|  |  |
|  |  |

NOTES:

# KILN INVENTORY

FIRING #:                TYPE:

DATE:          CONE:          START TIME:

| OBJECT | QUANTITY |
|--------|----------|
|        |          |
|        |          |
|        |          |
|        |          |
|        |          |
|        |          |
|        |          |
|        |          |
|        |          |
|        |          |
|        |          |
|        |          |
|        |          |
|        |          |
|        |          |
|        |          |
|        |          |
|        |          |
|        |          |
|        |          |
|        |          |
|        |          |
|        |          |

NOTES:

FIRING #:                TYPE:

DATE:          CONE:          START TIME:

| OBJECT | QUANTITY |
|--------|----------|
|        |          |
|        |          |
|        |          |
|        |          |
|        |          |
|        |          |
|        |          |
|        |          |
|        |          |
|        |          |
|        |          |
|        |          |
|        |          |
|        |          |
|        |          |
|        |          |
|        |          |
|        |          |
|        |          |
|        |          |
|        |          |
|        |          |
|        |          |

NOTES:

| FIRING #: | TYPE: | |
|---|---|---|
| DATE: | CONE: | START TIME: |

| OBJECT | QUANTITY |
|---|---|
| | |
| | |
| | |
| | |
| | |
| | |
| | |
| | |
| | |
| | |
| | |
| | |
| | |
| | |
| | |
| | |
| | |
| | |
| | |
| | |
| | |
| | |

NOTES:

| FIRING #: | TYPE: | |
|---|---|---|
| DATE: | CONE: | START TIME: |

| OBJECT | QUANTITY |
|---|---|
| | |
| | |
| | |
| | |
| | |
| | |
| | |
| | |
| | |
| | |
| | |
| | |
| | |
| | |
| | |
| | |
| | |
| | |
| | |
| | |
| | |
| | |

NOTES:

# KILN INVENTORY

FIRING #:                TYPE:

DATE:          CONE:        START TIME:

| OBJECT | QUANTITY |
|---|---|
|  |  |
|  |  |
|  |  |
|  |  |
|  |  |
|  |  |
|  |  |
|  |  |
|  |  |
|  |  |
|  |  |
|  |  |
|  |  |
|  |  |
|  |  |
|  |  |
|  |  |
|  |  |
|  |  |
|  |  |
|  |  |

NOTES:

FIRING #:                TYPE:

DATE:          CONE:        START TIME:

| OBJECT | QUANTITY |
|---|---|
|  |  |
|  |  |
|  |  |
|  |  |
|  |  |
|  |  |
|  |  |
|  |  |
|  |  |
|  |  |
|  |  |
|  |  |
|  |  |
|  |  |
|  |  |
|  |  |
|  |  |
|  |  |
|  |  |
|  |  |
|  |  |

NOTES:

FIRING #:          TYPE:

DATE:        CONE:          START TIME:

| OBJECT | QUANTITY |
|---|---|
| | |
| | |
| | |
| | |
| | |
| | |
| | |
| | |
| | |
| | |
| | |
| | |
| | |
| | |
| | |
| | |
| | |
| | |
| | |
| | |
| | |
| | |
| | |
| | |
| | |

NOTES:

FIRING #:          TYPE:

DATE:        CONE:          START TIME:

| OBJECT | QUANTITY |
|---|---|
| | |
| | |
| | |
| | |
| | |
| | |
| | |
| | |
| | |
| | |
| | |
| | |
| | |
| | |
| | |
| | |
| | |
| | |
| | |
| | |
| | |
| | |
| | |
| | |
| | |

NOTES:

# KILN INVENTORY

FIRING #:                TYPE:

DATE:          CONE:          START TIME:

FIRING #:                TYPE:

DATE:          CONE:          START TIME:

| OBJECT | QUANTITY | OBJECT | QUANTITY |
|---|---|---|---|
| | | | |
| | | | |
| | | | |
| | | | |
| | | | |
| | | | |
| | | | |
| | | | |
| | | | |
| | | | |
| | | | |
| | | | |
| | | | |
| | | | |
| | | | |
| | | | |
| | | | |
| | | | |
| | | | |
| | | | |
| | | | |
| | | | |
| | | | |
| | | | |
| | | | |
| | | | |

NOTES:

NOTES:

FIRING #:       TYPE:

DATE:    CONE:    START TIME:

| OBJECT | QUANTITY |
|--------|----------|
|        |          |
|        |          |
|        |          |
|        |          |
|        |          |
|        |          |
|        |          |
|        |          |
|        |          |
|        |          |
|        |          |
|        |          |
|        |          |
|        |          |
|        |          |
|        |          |
|        |          |
|        |          |
|        |          |
|        |          |
|        |          |
|        |          |
|        |          |

NOTES:

FIRING #:       TYPE:

DATE:    CONE:    START TIME:

| OBJECT | QUANTITY |
|--------|----------|
|        |          |
|        |          |
|        |          |
|        |          |
|        |          |
|        |          |
|        |          |
|        |          |
|        |          |
|        |          |
|        |          |
|        |          |
|        |          |
|        |          |
|        |          |
|        |          |
|        |          |
|        |          |
|        |          |
|        |          |
|        |          |
|        |          |
|        |          |

NOTES:

# KILN INVENTORY

FIRING #:          TYPE:                    FIRING #:          TYPE:

DATE:          CONE:          START TIME:          DATE:          CONE:          START TIME:

| OBJECT | QUANTITY |
|--------|----------|
|        |          |
|        |          |
|        |          |
|        |          |
|        |          |
|        |          |
|        |          |
|        |          |
|        |          |
|        |          |
|        |          |
|        |          |
|        |          |
|        |          |
|        |          |
|        |          |
|        |          |
|        |          |
|        |          |
|        |          |

| OBJECT | QUANTITY |
|--------|----------|
|        |          |
|        |          |
|        |          |
|        |          |
|        |          |
|        |          |
|        |          |
|        |          |
|        |          |
|        |          |
|        |          |
|        |          |
|        |          |
|        |          |
|        |          |
|        |          |
|        |          |
|        |          |
|        |          |
|        |          |

NOTES:

NOTES:

FIRING #:          TYPE:

DATE:      CONE:      START TIME:

| OBJECT | QUANTITY |
|---|---|
|  |  |
|  |  |
|  |  |
|  |  |
|  |  |
|  |  |
|  |  |
|  |  |
|  |  |
|  |  |
|  |  |
|  |  |
|  |  |
|  |  |
|  |  |
|  |  |
|  |  |
|  |  |
|  |  |
|  |  |
|  |  |
|  |  |

NOTES:

FIRING #:          TYPE:

DATE:      CONE:      START TIME:

| OBJECT | QUANTITY |
|---|---|
|  |  |
|  |  |
|  |  |
|  |  |
|  |  |
|  |  |
|  |  |
|  |  |
|  |  |
|  |  |
|  |  |
|  |  |
|  |  |
|  |  |
|  |  |
|  |  |
|  |  |
|  |  |
|  |  |
|  |  |
|  |  |
|  |  |

NOTES:

# KILN INVENTORY

FIRING #:                    TYPE:

DATE:          CONE:         START TIME:

| OBJECT | QUANTITY |
|--------|----------|
|        |          |
|        |          |
|        |          |
|        |          |
|        |          |
|        |          |
|        |          |
|        |          |
|        |          |
|        |          |
|        |          |
|        |          |
|        |          |
|        |          |
|        |          |
|        |          |
|        |          |
|        |          |
|        |          |
|        |          |
|        |          |
|        |          |

NOTES:

FIRING #:                    TYPE:

DATE:          CONE:         START TIME:

| OBJECT | QUANTITY |
|--------|----------|
|        |          |
|        |          |
|        |          |
|        |          |
|        |          |
|        |          |
|        |          |
|        |          |
|        |          |
|        |          |
|        |          |
|        |          |
|        |          |
|        |          |
|        |          |
|        |          |
|        |          |
|        |          |
|        |          |
|        |          |
|        |          |
|        |          |

NOTES:

FIRING #:         TYPE:

DATE:      CONE:      START TIME:

| OBJECT | QUANTITY |
|---|---|
|  |  |
|  |  |
|  |  |
|  |  |
|  |  |
|  |  |
|  |  |
|  |  |
|  |  |
|  |  |
|  |  |
|  |  |
|  |  |
|  |  |
|  |  |
|  |  |
|  |  |
|  |  |
|  |  |
|  |  |
|  |  |
|  |  |
|  |  |
|  |  |

NOTES:

FIRING #:         TYPE:

DATE:      CONE:      START TIME:

| OBJECT | QUANTITY |
|---|---|
|  |  |
|  |  |
|  |  |
|  |  |
|  |  |
|  |  |
|  |  |
|  |  |
|  |  |
|  |  |
|  |  |
|  |  |
|  |  |
|  |  |
|  |  |
|  |  |
|  |  |
|  |  |
|  |  |
|  |  |
|  |  |
|  |  |
|  |  |
|  |  |

NOTES:

# KILN INVENTORY

FIRING #:                TYPE:

DATE:        CONE:        START TIME:

| OBJECT | QUANTITY |
|---|---|
|  |  |
|  |  |
|  |  |
|  |  |
|  |  |
|  |  |
|  |  |
|  |  |
|  |  |
|  |  |
|  |  |
|  |  |
|  |  |
|  |  |
|  |  |
|  |  |
|  |  |
|  |  |
|  |  |
|  |  |
|  |  |
|  |  |

NOTES:

FIRING #:                TYPE:

DATE:        CONE:        START TIME:

| OBJECT | QUANTITY |
|---|---|
|  |  |
|  |  |
|  |  |
|  |  |
|  |  |
|  |  |
|  |  |
|  |  |
|  |  |
|  |  |
|  |  |
|  |  |
|  |  |
|  |  |
|  |  |
|  |  |
|  |  |
|  |  |
|  |  |
|  |  |
|  |  |
|  |  |

NOTES:

FIRING #:        TYPE:

DATE:     CONE:     START TIME:

| OBJECT | QUANTITY |
|---|---|
| | |
| | |
| | |
| | |
| | |
| | |
| | |
| | |
| | |
| | |
| | |
| | |
| | |
| | |
| | |
| | |
| | |
| | |
| | |
| | |
| | |

NOTES:

FIRING #:        TYPE:

DATE:     CONE:     START TIME:

| OBJECT | QUANTITY |
|---|---|
| | |
| | |
| | |
| | |
| | |
| | |
| | |
| | |
| | |
| | |
| | |
| | |
| | |
| | |
| | |
| | |
| | |
| | |
| | |
| | |
| | |

NOTES:

# KILN INVENTORY

FIRING #:                TYPE:

DATE:          CONE:          START TIME:

| OBJECT | QUANTITY |
|--------|----------|
|        |          |
|        |          |
|        |          |
|        |          |
|        |          |
|        |          |
|        |          |
|        |          |
|        |          |
|        |          |
|        |          |
|        |          |
|        |          |
|        |          |
|        |          |
|        |          |
|        |          |
|        |          |
|        |          |
|        |          |
|        |          |
|        |          |

NOTES:

FIRING #:                TYPE:

DATE:          CONE:          START TIME:

| OBJECT | QUANTITY |
|--------|----------|
|        |          |
|        |          |
|        |          |
|        |          |
|        |          |
|        |          |
|        |          |
|        |          |
|        |          |
|        |          |
|        |          |
|        |          |
|        |          |
|        |          |
|        |          |
|        |          |
|        |          |
|        |          |
|        |          |
|        |          |
|        |          |
|        |          |

NOTES:

FIRING #:                 TYPE:

DATE:          CONE:           START TIME:

| OBJECT | QUANTITY |
|--------|----------|
|        |          |
|        |          |
|        |          |
|        |          |
|        |          |
|        |          |
|        |          |
|        |          |
|        |          |
|        |          |
|        |          |
|        |          |
|        |          |
|        |          |
|        |          |
|        |          |
|        |          |
|        |          |
|        |          |
|        |          |
|        |          |
|        |          |

NOTES:

FIRING #:                 TYPE:

DATE:          CONE:           START TIME:

| OBJECT | QUANTITY |
|--------|----------|
|        |          |
|        |          |
|        |          |
|        |          |
|        |          |
|        |          |
|        |          |
|        |          |
|        |          |
|        |          |
|        |          |
|        |          |
|        |          |
|        |          |
|        |          |
|        |          |
|        |          |
|        |          |
|        |          |
|        |          |
|        |          |
|        |          |

NOTES:

# KILN INVENTORY

FIRING #:                    TYPE:

DATE:          CONE:         START TIME:

| OBJECT | QUANTITY |
|--------|----------|
|        |          |
|        |          |
|        |          |
|        |          |
|        |          |
|        |          |
|        |          |
|        |          |
|        |          |
|        |          |
|        |          |
|        |          |
|        |          |
|        |          |
|        |          |
|        |          |
|        |          |
|        |          |
|        |          |
|        |          |
|        |          |

NOTES:

FIRING #:                    TYPE:

DATE:          CONE:         START TIME:

| OBJECT | QUANTITY |
|--------|----------|
|        |          |
|        |          |
|        |          |
|        |          |
|        |          |
|        |          |
|        |          |
|        |          |
|        |          |
|        |          |
|        |          |
|        |          |
|        |          |
|        |          |
|        |          |
|        |          |
|        |          |
|        |          |
|        |          |
|        |          |
|        |          |

NOTES:

FIRING #:              TYPE:

DATE:        CONE:      START TIME:

| OBJECT | QUANTITY |
|--------|----------|
|        |          |
|        |          |
|        |          |
|        |          |
|        |          |
|        |          |
|        |          |
|        |          |
|        |          |
|        |          |
|        |          |
|        |          |
|        |          |
|        |          |
|        |          |
|        |          |
|        |          |
|        |          |
|        |          |
|        |          |
|        |          |

NOTES:

FIRING #:              TYPE:

DATE:        CONE:      START TIME:

| OBJECT | QUANTITY |
|--------|----------|
|        |          |
|        |          |
|        |          |
|        |          |
|        |          |
|        |          |
|        |          |
|        |          |
|        |          |
|        |          |
|        |          |
|        |          |
|        |          |
|        |          |
|        |          |
|        |          |
|        |          |
|        |          |
|        |          |
|        |          |
|        |          |

NOTES:

# KILN INVENTORY

FIRING #:                    TYPE:

DATE:          CONE:         START TIME:

| OBJECT | QUANTITY |
|--------|----------|
|        |          |
|        |          |
|        |          |
|        |          |
|        |          |
|        |          |
|        |          |
|        |          |
|        |          |
|        |          |
|        |          |
|        |          |
|        |          |
|        |          |
|        |          |
|        |          |
|        |          |
|        |          |
|        |          |
|        |          |
|        |          |
|        |          |
|        |          |

NOTES:

FIRING #:                    TYPE:

DATE:          CONE:         START TIME:

| OBJECT | QUANTITY |
|--------|----------|
|        |          |
|        |          |
|        |          |
|        |          |
|        |          |
|        |          |
|        |          |
|        |          |
|        |          |
|        |          |
|        |          |
|        |          |
|        |          |
|        |          |
|        |          |
|        |          |
|        |          |
|        |          |
|        |          |
|        |          |
|        |          |
|        |          |
|        |          |

NOTES:

FIRING #:          TYPE:

DATE:      CONE:      START TIME:

| OBJECT | QUANTITY |
|---|---|
| | |
| | |
| | |
| | |
| | |
| | |
| | |
| | |
| | |
| | |
| | |
| | |
| | |
| | |
| | |
| | |
| | |
| | |
| | |
| | |
| | |
| | |
| | |
| | |

NOTES:

FIRING #:          TYPE:

DATE:      CONE:      START TIME:

| OBJECT | QUANTITY |
|---|---|
| | |
| | |
| | |
| | |
| | |
| | |
| | |
| | |
| | |
| | |
| | |
| | |
| | |
| | |
| | |
| | |
| | |
| | |
| | |
| | |
| | |
| | |
| | |
| | |

NOTES:

# FIRING SCHEDULE TRACKER

FIRING TYPE:

TARGET TEMP:

| | |
|---|---|
| RAMP 1 | |
| RAMP 2 | |
| RAMP 3 | |
| RAMP 4 | |
| RAMP5 | |
| RAMP 6 | |
| RAMP 7 | |
| RAMP 8 | |
| RAMP 9 | |
| RAMP 10 | |
| RAMP 11 | |
| RAMP 12 | |
| RAMP 13 | |
| RAMP 14 | |
| RAMP 15 | |
| RANP 16 | |

NOTES

FIRING TYPE:

TARGET TEMP:

| | |
|---|---|
| RAMP 1 | |
| RAMP 2 | |
| RAMP 3 | |
| RAMP 4 | |
| RAMP5 | |
| RAMP 6 | |
| RAMP 7 | |
| RAMP 8 | |
| RAMP 9 | |
| RAMP 10 | |
| RAMP 11 | |
| RAMP 12 | |
| RAMP 13 | |
| RAMP 14 | |
| RAMP 15 | |
| RANP 16 | |

NOTES

**FIRING TYPE:**

**TARGET TEMP:**

| | |
|---|---|
| RAMP 1 | |
| RAMP 2 | |
| RAMP 3 | |
| RAMP 4 | |
| RAMP 5 | |
| RAMP 6 | |
| RAMP 7 | |
| RAMP 8 | |
| RAMP 9 | |
| RAMP 10 | |
| RAMP 11 | |
| RAMP 12 | |
| RAMP 13 | |
| RAMP 14 | |
| RAMP 15 | |
| RANP 16 | |

NOTES

**FIRING TYPE:**

**TARET TEMP:**

| | |
|---|---|
| RAMP 1 | |
| RAMP 2 | |
| RAMP 3 | |
| RAMP 4 | |
| RAMP 5 | |
| RAMP 6 | |
| RAMP 7 | |
| RAMP 8 | |
| RAMP 9 | |
| RAMP 10 | |
| RAMP 11 | |
| RAMP 12 | |
| RAMP 13 | |
| RAMP 14 | |
| RAMP 15 | |
| RANP 16 | |

NOTES

# FIRING SCHEDULE TRACKER

FIRING TYPE:

TARGET TEMP:

| | | NOTES |
|---|---|---|
| RAMP 1 | | |
| RAMP 2 | | |
| RAMP 3 | | |
| RAMP 4 | | |
| RAMP5 | | |
| RAMP 6 | | |
| RAMP 7 | | |
| RAMP 8 | | |
| RAMP 9 | | |
| RAMP 10 | | |
| RAMP 11 | | |
| RAMP 12 | | |
| RAMP 13 | | |
| RAMP 14 | | |
| RAMP 15 | | |
| RANP 16 | | |

FIRING TYPE:

TARGET TEMP:

| | | NOTES |
|---|---|---|
| RAMP 1 | | |
| RAMP 2 | | |
| RAMP 3 | | |
| RAMP 4 | | |
| RAMP5 | | |
| RAMP 6 | | |
| RAMP 7 | | |
| RAMP 8 | | |
| RAMP 9 | | |
| RAMP 10 | | |
| RAMP 11 | | |
| RAMP 12 | | |
| RAMP 13 | | |
| RAMP 14 | | |
| RAMP 15 | | |
| RANP 16 | | |

FIRING TYPE:

TARGET TEMP:

| | |
|---|---|
| RAMP 1 | |
| RAMP 2 | |
| RAMP 3 | |
| RAMP 4 | |
| RAMP5 | |
| RAMP 6 | |
| RAMP 7 | |
| RAMP 8 | |
| RAMP 9 | |
| RAMP 10 | |
| RAMP 11 | |
| RAMP 12 | |
| RAMP 13 | |
| RAMP 14 | |
| RAMP 15 | |
| RANP 16 | |

NOTES

FIRING TYPE:

TARET TEMP:

| | |
|---|---|
| RAMP 1 | |
| RAMP 2 | |
| RAMP 3 | |
| RAMP 4 | |
| RAMP5 | |
| RAMP 6 | |
| RAMP 7 | |
| RAMP 8 | |
| RAMP 9 | |
| RAMP 10 | |
| RAMP 11 | |
| RAMP 12 | |
| RAMP 13 | |
| RAMP 14 | |
| RAMP 15 | |
| RANP 16 | |

NOTES

# FIRING SCHEDULE TRACKER

FIRING TYPE:

TARGET TEMP:

| | |
|---|---|
| RAMP 1 | |
| RAMP 2 | |
| RAMP 3 | |
| RAMP 4 | |
| RAMP5 | |
| RAMP 6 | |
| RAMP 7 | |
| RAMP 8 | |
| RAMP 9 | |
| RAMP 10 | |
| RAMP 11 | |
| RAMP 12 | |
| RAMP 13 | |
| RAMP 14 | |
| RAMP 15 | |
| RANP 16 | |

NOTES

FIRING TYPE:

TARGET TEMP:

| | |
|---|---|
| RAMP 1 | |
| RAMP 2 | |
| RAMP 3 | |
| RAMP 4 | |
| RAMP5 | |
| RAMP 6 | |
| RAMP 7 | |
| RAMP 8 | |
| RAMP 9 | |
| RAMP 10 | |
| RAMP 11 | |
| RAMP 12 | |
| RAMP 13 | |
| RAMP 14 | |
| RAMP 15 | |
| RANP 16 | |

NOTES

**FIRING TYPE:**

**TARGET TEMP:**

| | |
|---|---|
| RAMP 1 | |
| RAMP 2 | |
| RAMP 3 | |
| RAMP 4 | |
| RAMP5 | |
| RAMP 6 | |
| RAMP 7 | |
| RAMP 8 | |
| RAMP 9 | |
| RAMP 10 | |
| RAMP 11 | |
| RAMP 12 | |
| RAMP 13 | |
| RAMP 14 | |
| RAMP 15 | |
| RANP 16 | |

NOTES

**FIRING TYPE:**

**TARET TEMP:**

| | |
|---|---|
| RAMP 1 | |
| RAMP 2 | |
| RAMP 3 | |
| RAMP 4 | |
| RAMP5 | |
| RAMP 6 | |
| RAMP 7 | |
| RAMP 8 | |
| RAMP 9 | |
| RAMP 10 | |
| RAMP 11 | |
| RAMP 12 | |
| RAMP 13 | |
| RAMP 14 | |
| RAMP 15 | |
| RANP 16 | |

NOTES

# Planner

YEARLY PLAN

| | 1 | 2 | 3 | 4 | 5 | 6 | 7 | 8 | 9 | 10 | 11 | 12 | 13 | 14 |
|---|---|---|---|---|---|---|---|---|---|----|----|----|----|----|
| | | | | | | | | | | | | | | |
| | | | | | | | | | | | | | | |
| | | | | | | | | | | | | | | |
| | | | | | | | | | | | | | | |
| | | | | | | | | | | | | | | |
| | | | | | | | | | | | | | | |
| | | | | | | | | | | | | | | |
| | | | | | | | | | | | | | | |
| | | | | | | | | | | | | | | |
| | | | | | | | | | | | | | | |
| | | | | | | | | | | | | | | |
| | | | | | | | | | | | | | | |

| 17 | 18 | 19 | 20 | 21 | 22 | 23 | 24 | 25 | 26 | 27 | 28 | 29 | 30 | 31 |
|----|----|----|----|----|----|----|----|----|----|----|----|----|----|----|
|    |    |    |    |    |    |    |    |    |    |    |    |    |    |    |
|    |    |    |    |    |    |    |    |    |    |    |    |    |    |    |
|    |    |    |    |    |    |    |    |    |    |    |    |    |    |    |
|    |    |    |    |    |    |    |    |    |    |    |    |    |    |    |
|    |    |    |    |    |    |    |    |    |    |    |    |    |    |    |
|    |    |    |    |    |    |    |    |    |    |    |    |    |    |    |
|    |    |    |    |    |    |    |    |    |    |    |    |    |    |    |
|    |    |    |    |    |    |    |    |    |    |    |    |    |    |    |
|    |    |    |    |    |    |    |    |    |    |    |    |    |    |    |
|    |    |    |    |    |    |    |    |    |    |    |    |    |    |    |
|    |    |    |    |    |    |    |    |    |    |    |    |    |    |    |
|    |    |    |    |    |    |    |    |    |    |    |    |    |    |    |

YEARLY PLAN

|  | 1 | 2 | 3 | 4 | 5 | 6 | 7 | 8 | 9 | 10 | 11 | 12 | 13 | 14 |
|---|---|---|---|---|---|---|---|---|---|---|---|---|---|---|
|  |  |  |  |  |  |  |  |  |  |  |  |  |  |  |
|  |  |  |  |  |  |  |  |  |  |  |  |  |  |  |
|  |  |  |  |  |  |  |  |  |  |  |  |  |  |  |
|  |  |  |  |  |  |  |  |  |  |  |  |  |  |  |
|  |  |  |  |  |  |  |  |  |  |  |  |  |  |  |
|  |  |  |  |  |  |  |  |  |  |  |  |  |  |  |
|  |  |  |  |  |  |  |  |  |  |  |  |  |  |  |
|  |  |  |  |  |  |  |  |  |  |  |  |  |  |  |
|  |  |  |  |  |  |  |  |  |  |  |  |  |  |  |
|  |  |  |  |  |  |  |  |  |  |  |  |  |  |  |
|  |  |  |  |  |  |  |  |  |  |  |  |  |  |  |

| 17 | 18 | 19 | 20 | 21 | 22 | 23 | 24 | 25 | 26 | 27 | 28 | 29 | 30 | 31 |
|----|----|----|----|----|----|----|----|----|----|----|----|----|----|----|
|    |    |    |    |    |    |    |    |    |    |    |    |    |    |    |
|    |    |    |    |    |    |    |    |    |    |    |    |    |    |    |
|    |    |    |    |    |    |    |    |    |    |    |    |    |    |    |
|    |    |    |    |    |    |    |    |    |    |    |    |    |    |    |
|    |    |    |    |    |    |    |    |    |    |    |    |    |    |    |
|    |    |    |    |    |    |    |    |    |    |    |    |    |    |    |
|    |    |    |    |    |    |    |    |    |    |    |    |    |    |    |
|    |    |    |    |    |    |    |    |    |    |    |    |    |    |    |
|    |    |    |    |    |    |    |    |    |    |    |    |    |    |    |
|    |    |    |    |    |    |    |    |    |    |    |    |    |    |    |
|    |    |    |    |    |    |    |    |    |    |    |    |    |    |    |

YEARLY PLAN

| | 1 | 2 | 3 | 4 | 5 | 6 | 7 | 8 | 9 | 10 | 11 | 12 | 13 | 14 |
|---|---|---|---|---|---|---|---|---|---|----|----|----|----|----|
| | | | | | | | | | | | | | | |
| | | | | | | | | | | | | | | |
| | | | | | | | | | | | | | | |
| | | | | | | | | | | | | | | |
| | | | | | | | | | | | | | | |
| | | | | | | | | | | | | | | |
| | | | | | | | | | | | | | | |
| | | | | | | | | | | | | | | |
| | | | | | | | | | | | | | | |
| | | | | | | | | | | | | | | |
| | | | | | | | | | | | | | | |
| | | | | | | | | | | | | | | |

| 17 | 18 | 19 | 20 | 21 | 22 | 23 | 24 | 25 | 26 | 27 | 28 | 29 | 30 | 31 |
|----|----|----|----|----|----|----|----|----|----|----|----|----|----|----|
|    |    |    |    |    |    |    |    |    |    |    |    |    |    |    |
|    |    |    |    |    |    |    |    |    |    |    |    |    |    |    |
|    |    |    |    |    |    |    |    |    |    |    |    |    |    |    |
|    |    |    |    |    |    |    |    |    |    |    |    |    |    |    |
|    |    |    |    |    |    |    |    |    |    |    |    |    |    |    |
|    |    |    |    |    |    |    |    |    |    |    |    |    |    |    |
|    |    |    |    |    |    |    |    |    |    |    |    |    |    |    |
|    |    |    |    |    |    |    |    |    |    |    |    |    |    |    |
|    |    |    |    |    |    |    |    |    |    |    |    |    |    |    |
|    |    |    |    |    |    |    |    |    |    |    |    |    |    |    |
|    |    |    |    |    |    |    |    |    |    |    |    |    |    |    |
|    |    |    |    |    |    |    |    |    |    |    |    |    |    |    |

MONTHLY PLAN _____

| GOALS | MONDAY | TUESDAY | WEDNESDAY |
|---|---|---|---|
| | — | — | — |
| | — | — | — |
| | — | — | — |
| | — | — | — |
| | — | — | — |
| | — | — | — |

| THURSDAY | FRIDAY | SATURDAY | SUNDAY |
|---|---|---|---|
| | — | — | — |
| | — | — | — |
| | — | — | — |
| | — | — | — |
| | — | — | — |
| | — | — | — |

| GOALS | MONDAY | TUESDAY | WEDNESDAY |
|---|---|---|---|
| | —— | —— | —— |
| | —— | —— | —— |
| | —— | —— | —— |
| | —— | —— | —— |
| | —— | —— | —— |
| | —— | —— | —— |

| THURSDAY | FRIDAY | SATURDAY | SUNDAY |
|---|---|---|---|
| | — | — | — |
| | — | — | — |
| | — | — | — |
| | — | — | — |
| | — | — | — |
| | — | — | — |

MONTHLY PLAN _____

| GOALS | MONDAY | TUESDAY | WEDNESDAY |
|-------|--------|---------|-----------|
| | — | — | — |
| | — | — | — |
| | — | — | — |
| | — | — | — |
| | — | — | — |
| | — | — | — |

| THURSDAY | FRIDAY | SATURDAY | SUNDAY |
|----------|--------|----------|--------|
|          |        |          |        |
|          |        |          |        |
|          |        |          |        |
|          |        |          |        |
|          |        |          |        |
|          |        |          |        |

MONTHLY PLAN _____

| GOALS | MONDAY | TUESDAY | WEDNESDAY |
|---|---|---|---|
|  | —— | —— | —— |
|  | —— | —— | —— |
|  | —— | —— | —— |
|  | —— | —— | —— |
|  | —— | —— | —— |
|  | —— | —— | —— |

| THURSDAY | FRIDAY | SATURDAY | SUNDAY |
|----------|--------|----------|--------|
|          | —      | —        | —      |
|          | —      | —        | —      |
|          | —      | —        | —      |
|          | —      | —        | —      |
|          | —      | —        | —      |
|          | —      | —        | —      |

MONTHLY PLAN _____

| GOALS | MONDAY | TUESDAY | WEDNESDAY |
|-------|--------|---------|-----------|
| | —— | —— | —— |
| | —— | —— | —— |
| | —— | —— | —— |
| | —— | —— | —— |
| | —— | —— | —— |
| | —— | —— | —— |

| GOALS | MONDAY | TUESDAY | WEDNESDAY |
|-------|--------|---------|-----------|

| THURSDAY | FRIDAY | SATURDAY | SUNDAY |
|---|---|---|---|
| | — | — | — |
| | — | — | — |
| | — | — | — |
| | — | — | — |
| | — | — | — |
| | — | — | — |

MONTHLY PLAN _____

| GOALS | MONDAY | TUESDAY | WEDNESDAY |
|-------|--------|---------|-----------|
|       | ——     | ——      | ——        |
|       | ——     | ——      | ——        |
|       | ——     | ——      | ——        |
|       | ——     | ——      | ——        |
|       | ——     | ——      | ——        |
|       | ——     | ——      | ——        |

| THURSDAY | FRIDAY | SATURDAY | SUNDAY |
|---|---|---|---|
| | — | — | — |
| | — | — | — |
| | — | — | — |
| | — | — | — |
| | — | — | — |
| | — | — | — |

| GOALS | MONDAY | TUESDAY | WEDNESDAY |
|-------|--------|---------|-----------|
|  | —— | —— | —— |
|  | —— | —— | —— |
|  | —— | —— | —— |
|  | —— | —— | —— |
|  | —— | —— | —— |
|  | —— | —— | —— |

| THURSDAY | FRIDAY | SATURDAY | SUNDAY |
|----------|--------|----------|--------|
| | —— | —— | —— |
| | —— | —— | —— |
| | —— | —— | —— |
| | —— | —— | —— |
| | —— | —— | —— |
| | —— | —— | —— |

MONTHLY PLAN _____

| GOALS | MONDAY | TUESDAY | WEDNESDAY |
|---|---|---|---|
| | — | — | — |
| | — | — | — |
| | — | — | — |
| | — | — | — |
| | — | — | — |
| | — | — | — |

| THURSDAY | FRIDAY | SATURDAY | SUNDAY |
|---|---|---|---|
| | — | — | — |
| | — | — | — |
| | — | — | — |
| | — | — | — |
| | — | — | — |
| | — | — | — |

MONTHLY PLAN _____

| GOALS | MONDAY | TUESDAY | WEDNESDAY |
|-------|--------|---------|-----------|
|       | ___    | ___     | ___       |
|       | ___    | ___     | ___       |
|       | ___    | ___     | ___       |
|       | ___    | ___     | ___       |
|       | ___    | ___     | ___       |
|       | ___    | ___     | ___       |

| THURSDAY | FRIDAY | SATURDAY | SUNDAY |
|---|---|---|---|
| | —— | —— | —— |
| | —— | —— | —— |
| | —— | —— | —— |
| | —— | —— | —— |
| | —— | —— | —— |
| | —— | —— | —— |

| GOALS | MONDAY | TUESDAY | WEDNESDAY |
|---|---|---|---|
| | —— | —— | —— |
| | —— | —— | —— |
| | —— | —— | —— |
| | —— | —— | —— |
| | —— | —— | —— |
| | —— | —— | —— |

| THURSDAY | FRIDAY | SATURDAY | SUNDAY |
|----------|--------|----------|--------|
|          | —      | —        | —      |
|          | —      | —        | —      |
|          | —      | —        | —      |
|          | —      | —        | —      |
|          | —      | —        | —      |
|          | —      | —        | —      |

MONTHLY PLAN _____

| GOALS | MONDAY | TUESDAY | WEDNESDAY |
|-------|--------|---------|-----------|
| | — | — | — |
| | — | — | — |
| | — | — | — |
| | — | — | — |
| | — | — | — |
| | — | — | — |

| THURSDAY | FRIDAY | SATURDAY | SUNDAY |
|----------|--------|----------|--------|
|  | — | — | — |
|  | — | — | — |
|  | — | — | — |
|  | — | — | — |
|  | — | — | — |
|  | — | — | — |

MONTHLY PLAN _____

| GOALS | MONDAY | TUESDAY | WEDNESDAY |
|-------|--------|---------|-----------|
| | —— | —— | —— |
| | —— | —— | —— |
| | —— | —— | —— |
| | —— | —— | —— |
| | —— | —— | —— |
| | —— | —— | —— |

| THURSDAY | FRIDAY | SATURDAY | SUNDAY |
|---|---|---|---|
| | — | — | — |
| | — | — | — |
| | — | — | — |
| | — | — | — |
| | — | — | — |
| | — | — | — |

MONTHLY PLAN _____

| GOALS | MONDAY | TUESDAY | WEDNESDAY |
|-------|--------|---------|-----------|
| | — | — | — |
| | — | — | — |
| | — | — | — |
| | — | — | — |
| | — | — | — |
| | — | — | — |

| THURSDAY | FRIDAY | SATURDAY | SUNDAY |
|---|---|---|---|
| | | | |
| | | | |
| | | | |
| | | | |
| | | | |
| | | | |

MONTHLY PLAN _____

| GOALS | MONDAY | TUESDAY | WEDNESDAY |
|-------|--------|---------|-----------|
|       | ——     | ——      | ——        |
|       | ——     | ——      | ——        |
|       | ——     | ——      | ——        |
|       | ——     | ——      | ——        |
|       | ——     | ——      | ——        |
|       | ——     | ——      | ——        |

| THURSDAY | FRIDAY | SATURDAY | SUNDAY |
|---|---|---|---|
| | — | — | — |
| | — | — | — |
| | — | — | — |
| | — | — | — |
| | — | — | — |
| | — | — | — |

| GOALS | MONDAY | TUESDAY | WEDNESDAY |
|---|---|---|---|
| | —— | —— | —— |
| | —— | —— | —— |
| | —— | —— | —— |
| | —— | —— | —— |
| | —— | —— | —— |
| | —— | —— | —— |

| THURSDAY | FRIDAY | SATURDAY | SUNDAY |
|---|---|---|---|
| | | | |
| | | | |
| | | | |
| | | | |
| | | | |
| | | | |

MONTHLY PLAN _____

| GOALS | MONDAY | TUESDAY | WEDNESDAY |
|---|---|---|---|
| | — | — | — |
| | — | — | — |
| | — | — | — |
| | — | — | — |
| | — | — | — |
| | — | — | — |

| THURSDAY | FRIDAY | SATURDAY | SUNDAY |
|---|---|---|---|
| | | | |
| | | | |
| | | | |
| | | | |
| | | | |
| | | | |

| GOALS | MONDAY | TUESDAY | WEDNESDAY |
|---|---|---|---|
| | ___ | ___ | ___ |
| | ___ | ___ | ___ |
| | ___ | ___ | ___ |
| | ___ | ___ | ___ |
| | ___ | ___ | ___ |
| | ___ | ___ | ___ |

| THURSDAY | FRIDAY | SATURDAY | SUNDAY |
|---|---|---|---|
| | | | |
| | | | |
| | | | |
| | | | |
| | | | |
| | | | |

MONTHLY PLAN _____

| GOALS | MONDAY | TUESDAY | WEDNESDAY |
|---|---|---|---|
| | —— | —— | —— |
| | —— | —— | —— |
| | —— | —— | —— |
| | —— | —— | —— |
| | —— | —— | —— |
| | —— | —— | —— |

| THURSDAY | FRIDAY | SATURDAY | SUNDAY |
|---|---|---|---|
| | | | |
| | | | |
| | | | |
| | | | |
| | | | |
| | | | |

| GOALS | MONDAY | TUESDAY | WEDNESDAY |
|---|---|---|---|
| | — | — | — |
| | — | — | — |
| | — | — | — |
| | — | — | — |
| | — | — | — |
| | — | — | — |

| THURSDAY | FRIDAY | SATURDAY | SUNDAY |
|---|---|---|---|
| | | | |
| | | | |
| | | | |
| | | | |
| | | | |
| | | | |

| GOALS | MONDAY | TUESDAY | WEDNESDAY |
|-------|--------|---------|-----------|
| | — | — | — |
| | — | — | — |
| | — | — | — |
| | — | — | — |
| | — | — | — |
| | — | — | — |

| THURSDAY | FRIDAY | SATURDAY | SUNDAY |
|---|---|---|---|
| | | | |
| | | | |
| | | | |
| | | | |
| | | | |
| | | | |

MONTHLY PLAN _____

| GOALS | MONDAY | TUESDAY | WEDNESDAY |
|---|---|---|---|
| | — | — | — |
| | — | — | — |
| | — | — | — |
| | — | — | — |
| | — | — | — |
| | — | — | — |

| THURSDAY | FRIDAY | SATURDAY | SUNDAY |
|---|---|---|---|
| | | | |
| | | | |
| | | | |
| | | | |
| | | | |
| | | | |

MONTHLY PLAN _____

| GOALS | MONDAY | TUESDAY | WEDNESDAY |
|-------|--------|---------|-----------|
| | — | — | — |
| | — | — | — |
| | — | — | — |
| | — | — | — |
| | — | — | — |
| | — | — | — |

| THURSDAY | FRIDAY | SATURDAY | SUNDAY |
|----------|--------|----------|--------|
| | —— | —— | —— |
| | —— | —— | —— |
| | —— | —— | —— |
| | —— | —— | —— |
| | —— | —— | —— |
| | —— | —— | —— |

| GOALS | MONDAY | TUESDAY | WEDNESDAY |
|---|---|---|---|
| | —— | —— | —— |
| | —— | —— | —— |
| | —— | —— | —— |
| | —— | —— | —— |
| | —— | —— | —— |
| | —— | —— | —— |

| THURSDAY | FRIDAY | SATURDAY | SUNDAY |
|---|---|---|---|
| | | | |
| | | | |
| | | | |
| | | | |
| | | | |
| | | | |

MONTHLY PLAN _____

| GOALS | MONDAY | TUESDAY | WEDNESDAY |
|-------|--------|---------|-----------|
|  | — | — | — |
|  | — | — | — |
|  | — | — | — |
|  | — | — | — |
|  | — | — | — |
|  | — | — | — |

| THURSDAY | FRIDAY | SATURDAY | SUNDAY |
|---|---|---|---|
| | | | |
| | | | |
| | | | |
| | | | |
| | | | |
| | | | |

| GOALS | MONDAY | TUESDAY | WEDNESDAY |
|-------|--------|---------|-----------|
|       | —      | —       | —         |
|       | —      | —       | —         |
|       | —      | —       | —         |
|       | —      | —       | —         |
|       | —      | —       | —         |
|       | —      | —       | —         |

| THURSDAY | FRIDAY | SATURDAY | SUNDAY |
|---|---|---|---|
| | | | |
| | | | |
| | | | |
| | | | |
| | | | |
| | | | |

MONTHLY PLAN _____

| GOALS | MONDAY | TUESDAY | WEDNESDAY |
|-------|--------|---------|-----------|
| | — | — | — |
| | — | — | — |
| | — | — | — |
| | — | — | — |
| | — | — | — |
| | — | — | — |

| THURSDAY | FRIDAY | SATURDAY | SUNDAY |
|---|---|---|---|
| | — | — | — |
| | — | — | — |
| | — | — | — |
| | — | — | — |
| | — | — | — |
| | — | — | — |

MONTHLY PLAN _____

| GOALS | MONDAY | TUESDAY | WEDNESDAY |
|-------|--------|---------|-----------|
|       | —      | —       | —         |
|       | —      | —       | —         |
|       | —      | —       | —         |
|       | —      | —       | —         |
|       | —      | —       | —         |
|       | —      | —       | —         |

| THURSDAY | FRIDAY | SATURDAY | SUNDAY |
|---|---|---|---|
| — | — | — | — |
| — | — | — | — |
| — | — | — | — |
| — | — | — | — |
| — | — | — | — |
| — | — | — | — |

MONTHLY PLAN _____

| GOALS | MONDAY | TUESDAY | WEDNESDAY |
|-------|--------|---------|-----------|
|  | — | — | — |
|  | — | — | — |
|  | — | — | — |
|  | — | — | — |
|  | — | — | — |
|  | — | — | — |

| THURSDAY | FRIDAY | SATURDAY | SUNDAY |
|---|---|---|---|
| | | | |
| | | | |
| | | | |
| | | | |
| | | | |
| | | | |

| GOALS | MONDAY | TUESDAY | WEDNESDAY |
|---|---|---|---|
| | — | — | — |
| | — | — | — |
| | — | — | — |
| | — | — | — |
| | — | — | — |
| | — | — | — |

| THURSDAY | FRIDAY | SATURDAY | SUNDAY |
|---|---|---|---|
| — | — | — | — |
| — | — | — | — |
| — | — | — | — |
| — | — | — | — |
| — | — | — | — |
| — | — | — | — |

# MONTHLY PLAN _____

| GOALS | MONDAY | TUESDAY | WEDNESDAY |
|-------|--------|---------|-----------|
| | —— | —— | —— |
| | —— | —— | —— |
| | —— | —— | —— |
| | —— | —— | —— |
| | —— | —— | —— |
| | —— | —— | —— |

| THURSDAY | FRIDAY | SATURDAY | SUNDAY |
|---|---|---|---|
| | | | |
| | | | |
| | | | |
| | | | |
| | | | |
| | | | |

| GOALS | MONDAY | TUESDAY | WEDNESDAY |
|-------|--------|---------|-----------|
| | — | — | — |
| | — | — | — |
| | — | — | — |
| | — | — | |
| | — | — | — |
| | — | — | — |

| THURSDAY | FRIDAY | SATURDAY | SUNDAY |
|----------|--------|----------|--------|
| | — | — | — |
| — | — | — | — |
| — | — | — | — |
| — | — | — | — |
| — | — | — | — |
| — | — | — | — |

| GOALS | MONDAY | TUESDAY | WEDNESDAY |
|-------|--------|---------|-----------|
| | — | — | — |
| | — | — | — |
| | — | — | — |
| | — | — | — |
| | — | — | — |
| | — | — | — |

| THURSDAY | FRIDAY | SATURDAY | SUNDAY |
|---|---|---|---|
| | | | |
| | | | |
| | | | |
| | | | |
| | | | |
| | | | |

MONTHLY PLAN _____

| GOALS | MONDAY | TUESDAY | WEDNESDAY |
|-------|--------|---------|-----------|
|  | —— | —— | —— |
|  | —— | —— | —— |
|  | —— | —— | —— |
|  | —— | —— | —— |
|  | —— | —— | —— |
|  | —— | —— | —— |

| THURSDAY | FRIDAY | SATURDAY | SUNDAY |
|---|---|---|---|
| — | — | — | — |
| — | — | — | — |
| — | — | — | — |
| — | — | — | — |
| — | — | — | — |
| — | — | — | — |

# MONTHLY PLAN _____

| GOALS | MONDAY | TUESDAY | WEDNESDAY |
|---|---|---|---|
| | — | — | — |
| | — | — | — |
| | — | — | — |
| | — | — | — |
| | — | — | — |
| | — | — | — |

| THURSDAY | FRIDAY | SATURDAY | SUNDAY |
|----------|--------|----------|--------|
| | — | — | — |
| | — | — | — |
| | — | — | — |
| | — | — | — |
| | — | — | — |
| | — | — | — |

MONTHLY PLAN _____

| GOALS | MONDAY | TUESDAY | WEDNESDAY |
|-------|--------|---------|-----------|
| | — | — | — |
| | — | — | — |
| | — | — | — |
| | — | — | — |
| | — | — | — |
| | — | — | — |

| THURSDAY | FRIDAY | SATURDAY | SUNDAY |
|----------|--------|----------|--------|
| — | — | — | — |
| — | — | — | — |
| — | — | — | — |
| — | — | — | — |
| — | — | — | — |
| — | — | — | — |

MONTHLY PLAN _____

| GOALS | MONDAY | TUESDAY | WEDNESDAY |
|-------|--------|---------|-----------|
|  | — | — | — |
|  | — | — | — |
|  | — | — | — |
|  | — | — | — |
|  | — | — | — |
|  | — | — | — |

| THURSDAY | FRIDAY | SATURDAY | SUNDAY |
|---|---|---|---|
| | — | — | — |
| | — | — | — |
| | — | — | — |
| | — | — | — |
| | — | — | — |
| | — | — | — |

MAKING GOALS

SHOW:                                           DATE:

| QUANTITY | OBJECT | VARIATION | PRICE |
|----------|--------|-----------|-------|
|          |        |           |       |
|          |        |           |       |
|          |        |           |       |
|          |        |           |       |
|          |        |           |       |
|          |        |           |       |
|          |        |           |       |
|          |        |           |       |
|          |        |           |       |
|          |        |           |       |
|          |        |           |       |
|          |        |           |       |
|          |        |           |       |
|          |        |           |       |
|          |        |           |       |
|          |        |           |       |
|          |        |           |       |
|          |        |           |       |
|          |        |           |       |
|          |        |           |       |
|          |        |           |       |
|          |        |           |       |
|          |        |           |       |
|          |        |           |       |
|          |        |           |       |
|          |        |           |       |
|          |        |           |       |
|          |        |           |       |
|          |        |           |       |
|          |        |           |       |
|          |        |           |       |
|          |        |           |       |
|          |        |           |       |

SHOW: DATE:

| QUANTITY | OBJECT | VARIATION | PRICE |
|---|---|---|---|
| | | | |
| | | | |
| | | | |
| | | | |
| | | | |
| | | | |
| | | | |
| | | | |
| | | | |
| | | | |
| | | | |
| | | | |
| | | | |
| | | | |
| | | | |
| | | | |
| | | | |
| | | | |
| | | | |
| | | | |
| | | | |
| | | | |
| | | | |
| | | | |
| | | | |
| | | | |
| | | | |
| | | | |
| | | | |
| | | | |
| | | | |
| | | | |
| | | | |

MAKING GOALS

SHOW:                                          DATE:

| QUANTITY | OBJECT | VARIATION | PRICE |
|----------|--------|-----------|-------|
|          |        |           |       |
|          |        |           |       |
|          |        |           |       |
|          |        |           |       |
|          |        |           |       |
|          |        |           |       |
|          |        |           |       |
|          |        |           |       |
|          |        |           |       |
|          |        |           |       |
|          |        |           |       |
|          |        |           |       |
|          |        |           |       |
|          |        |           |       |
|          |        |           |       |
|          |        |           |       |
|          |        |           |       |
|          |        |           |       |
|          |        |           |       |
|          |        |           |       |
|          |        |           |       |
|          |        |           |       |
|          |        |           |       |
|          |        |           |       |
|          |        |           |       |
|          |        |           |       |
|          |        |           |       |
|          |        |           |       |
|          |        |           |       |
|          |        |           |       |
|          |        |           |       |
|          |        |           |       |

SHOW:                                    DATE:

| QUANTITY | OBJECT | VARIATION | PRICE |
|----------|--------|-----------|-------|
|          |        |           |       |
|          |        |           |       |
|          |        |           |       |
|          |        |           |       |
|          |        |           |       |
|          |        |           |       |
|          |        |           |       |
|          |        |           |       |
|          |        |           |       |
|          |        |           |       |
|          |        |           |       |
|          |        |           |       |
|          |        |           |       |
|          |        |           |       |
|          |        |           |       |
|          |        |           |       |
|          |        |           |       |
|          |        |           |       |
|          |        |           |       |
|          |        |           |       |
|          |        |           |       |
|          |        |           |       |
|          |        |           |       |
|          |        |           |       |
|          |        |           |       |
|          |        |           |       |
|          |        |           |       |
|          |        |           |       |
|          |        |           |       |
|          |        |           |       |
|          |        |           |       |
|          |        |           |       |
|          |        |           |       |
|          |        |           |       |
|          |        |           |       |

MAKING GOALS

SHOW:                                    DATE:

| QUANTITY | OBJECT | VARIATION | PRICE |
|----------|--------|-----------|-------|
|          |        |           |       |
|          |        |           |       |
|          |        |           |       |
|          |        |           |       |
|          |        |           |       |
|          |        |           |       |
|          |        |           |       |
|          |        |           |       |
|          |        |           |       |
|          |        |           |       |
|          |        |           |       |
|          |        |           |       |
|          |        |           |       |
|          |        |           |       |
|          |        |           |       |
|          |        |           |       |
|          |        |           |       |
|          |        |           |       |
|          |        |           |       |
|          |        |           |       |
|          |        |           |       |
|          |        |           |       |
|          |        |           |       |
|          |        |           |       |
|          |        |           |       |
|          |        |           |       |
|          |        |           |       |
|          |        |           |       |
|          |        |           |       |
|          |        |           |       |
|          |        |           |       |
|          |        |           |       |

SHOW:                                    DATE:

| QUANTITY | OBJECT | VARIATION | PRICE |
|----------|--------|-----------|-------|
|          |        |           |       |
|          |        |           |       |
|          |        |           |       |
|          |        |           |       |
|          |        |           |       |
|          |        |           |       |
|          |        |           |       |
|          |        |           |       |
|          |        |           |       |
|          |        |           |       |
|          |        |           |       |
|          |        |           |       |
|          |        |           |       |
|          |        |           |       |
|          |        |           |       |
|          |        |           |       |
|          |        |           |       |
|          |        |           |       |
|          |        |           |       |
|          |        |           |       |
|          |        |           |       |
|          |        |           |       |
|          |        |           |       |
|          |        |           |       |
|          |        |           |       |
|          |        |           |       |
|          |        |           |       |
|          |        |           |       |
|          |        |           |       |
|          |        |           |       |
|          |        |           |       |
|          |        |           |       |
|          |        |           |       |
|          |        |           |       |
|          |        |           |       |
|          |        |           |       |
|          |        |           |       |

MAKING GOALS

SHOW:                                                    DATE:

| QUANTITY | OBJECT | VARIATION | PRICE |
|----------|--------|-----------|-------|
|          |        |           |       |
|          |        |           |       |
|          |        |           |       |
|          |        |           |       |
|          |        |           |       |
|          |        |           |       |
|          |        |           |       |
|          |        |           |       |
|          |        |           |       |
|          |        |           |       |
|          |        |           |       |
|          |        |           |       |
|          |        |           |       |
|          |        |           |       |
|          |        |           |       |
|          |        |           |       |
|          |        |           |       |
|          |        |           |       |
|          |        |           |       |
|          |        |           |       |
|          |        |           |       |
|          |        |           |       |
|          |        |           |       |
|          |        |           |       |
|          |        |           |       |
|          |        |           |       |
|          |        |           |       |
|          |        |           |       |
|          |        |           |       |
|          |        |           |       |
|          |        |           |       |
|          |        |           |       |

SHOW:                                    DATE:

| QUANTITY | OBJECT | VARIATION | PRICE |
|----------|--------|-----------|-------|
|          |        |           |       |
|          |        |           |       |
|          |        |           |       |
|          |        |           |       |
|          |        |           |       |
|          |        |           |       |
|          |        |           |       |
|          |        |           |       |
|          |        |           |       |
|          |        |           |       |
|          |        |           |       |
|          |        |           |       |
|          |        |           |       |
|          |        |           |       |
|          |        |           |       |
|          |        |           |       |
|          |        |           |       |
|          |        |           |       |
|          |        |           |       |
|          |        |           |       |
|          |        |           |       |
|          |        |           |       |
|          |        |           |       |
|          |        |           |       |
|          |        |           |       |
|          |        |           |       |
|          |        |           |       |
|          |        |           |       |
|          |        |           |       |
|          |        |           |       |
|          |        |           |       |
|          |        |           |       |
|          |        |           |       |
|          |        |           |       |

MAKING GOALS

SHOW:                                              DATE:

| QUANTITY | OBJECT | VARIATION | PRICE |
|----------|--------|-----------|-------|
|          |        |           |       |
|          |        |           |       |
|          |        |           |       |
|          |        |           |       |
|          |        |           |       |
|          |        |           |       |
|          |        |           |       |
|          |        |           |       |
|          |        |           |       |
|          |        |           |       |
|          |        |           |       |
|          |        |           |       |
|          |        |           |       |
|          |        |           |       |
|          |        |           |       |
|          |        |           |       |
|          |        |           |       |
|          |        |           |       |
|          |        |           |       |
|          |        |           |       |
|          |        |           |       |
|          |        |           |       |
|          |        |           |       |
|          |        |           |       |
|          |        |           |       |
|          |        |           |       |
|          |        |           |       |
|          |        |           |       |
|          |        |           |       |
|          |        |           |       |
|          |        |           |       |
|          |        |           |       |
|          |        |           |       |
|          |        |           |       |
|          |        |           |       |

SHOW:                                    DATE:

| QUANTITY | OBJECT | VARIATION | PRICE |
|----------|--------|-----------|-------|
|          |        |           |       |
|          |        |           |       |
|          |        |           |       |
|          |        |           |       |
|          |        |           |       |
|          |        |           |       |
|          |        |           |       |
|          |        |           |       |
|          |        |           |       |
|          |        |           |       |
|          |        |           |       |
|          |        |           |       |
|          |        |           |       |
|          |        |           |       |
|          |        |           |       |
|          |        |           |       |
|          |        |           |       |
|          |        |           |       |
|          |        |           |       |
|          |        |           |       |
|          |        |           |       |
|          |        |           |       |
|          |        |           |       |
|          |        |           |       |
|          |        |           |       |
|          |        |           |       |
|          |        |           |       |
|          |        |           |       |
|          |        |           |       |
|          |        |           |       |
|          |        |           |       |
|          |        |           |       |
|          |        |           |       |
|          |        |           |       |

MAKING GOALS

SHOW:                                          DATE:

| QUANTITY | OBJECT | VARIATION | PRICE |
|----------|--------|-----------|-------|
|          |        |           |       |
|          |        |           |       |
|          |        |           |       |
|          |        |           |       |
|          |        |           |       |
|          |        |           |       |
|          |        |           |       |
|          |        |           |       |
|          |        |           |       |
|          |        |           |       |
|          |        |           |       |
|          |        |           |       |
|          |        |           |       |
|          |        |           |       |
|          |        |           |       |
|          |        |           |       |
|          |        |           |       |
|          |        |           |       |
|          |        |           |       |
|          |        |           |       |
|          |        |           |       |
|          |        |           |       |
|          |        |           |       |
|          |        |           |       |
|          |        |           |       |
|          |        |           |       |
|          |        |           |       |
|          |        |           |       |
|          |        |           |       |
|          |        |           |       |
|          |        |           |       |
|          |        |           |       |
|          |        |           |       |
|          |        |           |       |
|          |        |           |       |

SHOW:                                    DATE:

| QUANTITY | OBJECT | VARIATION | PRICE |
|----------|--------|-----------|-------|
|          |        |           |       |
|          |        |           |       |
|          |        |           |       |
|          |        |           |       |
|          |        |           |       |
|          |        |           |       |
|          |        |           |       |
|          |        |           |       |
|          |        |           |       |
|          |        |           |       |
|          |        |           |       |
|          |        |           |       |
|          |        |           |       |
|          |        |           |       |
|          |        |           |       |
|          |        |           |       |
|          |        |           |       |
|          |        |           |       |
|          |        |           |       |
|          |        |           |       |
|          |        |           |       |
|          |        |           |       |
|          |        |           |       |
|          |        |           |       |
|          |        |           |       |
|          |        |           |       |
|          |        |           |       |
|          |        |           |       |
|          |        |           |       |
|          |        |           |       |
|          |        |           |       |
|          |        |           |       |
|          |        |           |       |
|          |        |           |       |
|          |        |           |       |

MAKING GOALS

SHOW:                                    DATE:

| QUANTITY | OBJECT | VARIATION | PRICE |
|----------|--------|-----------|-------|
|          |        |           |       |
|          |        |           |       |
|          |        |           |       |
|          |        |           |       |
|          |        |           |       |
|          |        |           |       |
|          |        |           |       |
|          |        |           |       |
|          |        |           |       |
|          |        |           |       |
|          |        |           |       |
|          |        |           |       |
|          |        |           |       |
|          |        |           |       |
|          |        |           |       |
|          |        |           |       |
|          |        |           |       |
|          |        |           |       |
|          |        |           |       |
|          |        |           |       |
|          |        |           |       |
|          |        |           |       |
|          |        |           |       |
|          |        |           |       |
|          |        |           |       |
|          |        |           |       |
|          |        |           |       |
|          |        |           |       |
|          |        |           |       |
|          |        |           |       |
|          |        |           |       |
|          |        |           |       |
|          |        |           |       |
|          |        |           |       |

SHOW:                                  DATE:

| QUANTITY | OBJECT | VARIATION | PRICE |
|---|---|---|---|
|  |  |  |  |
|  |  |  |  |
|  |  |  |  |
|  |  |  |  |
|  |  |  |  |
|  |  |  |  |
|  |  |  |  |
|  |  |  |  |
|  |  |  |  |
|  |  |  |  |
|  |  |  |  |
|  |  |  |  |
|  |  |  |  |
|  |  |  |  |
|  |  |  |  |
|  |  |  |  |
|  |  |  |  |
|  |  |  |  |
|  |  |  |  |
|  |  |  |  |
|  |  |  |  |
|  |  |  |  |
|  |  |  |  |
|  |  |  |  |
|  |  |  |  |
|  |  |  |  |
|  |  |  |  |
|  |  |  |  |
|  |  |  |  |
|  |  |  |  |
|  |  |  |  |
|  |  |  |  |
|  |  |  |  |
|  |  |  |  |
|  |  |  |  |
|  |  |  |  |
|  |  |  |  |

MAKING GOALS

SHOW:                                            DATE:

| QUANTITY | OBJECT | VARIATION | PRICE |
|----------|--------|-----------|-------|
|          |        |           |       |
|          |        |           |       |
|          |        |           |       |
|          |        |           |       |
|          |        |           |       |
|          |        |           |       |
|          |        |           |       |
|          |        |           |       |
|          |        |           |       |
|          |        |           |       |
|          |        |           |       |
|          |        |           |       |
|          |        |           |       |
|          |        |           |       |
|          |        |           |       |
|          |        |           |       |
|          |        |           |       |
|          |        |           |       |
|          |        |           |       |
|          |        |           |       |
|          |        |           |       |
|          |        |           |       |
|          |        |           |       |
|          |        |           |       |
|          |        |           |       |
|          |        |           |       |
|          |        |           |       |
|          |        |           |       |
|          |        |           |       |
|          |        |           |       |
|          |        |           |       |
|          |        |           |       |
|          |        |           |       |
|          |        |           |       |

SHOW:                                          DATE:

| QUANTITY | OBJECT | VARIATION | PRICE |
|---|---|---|---|
| | | | |
| | | | |
| | | | |
| | | | |
| | | | |
| | | | |
| | | | |
| | | | |
| | | | |
| | | | |
| | | | |
| | | | |
| | | | |
| | | | |
| | | | |
| | | | |
| | | | |
| | | | |
| | | | |
| | | | |
| | | | |
| | | | |
| | | | |
| | | | |
| | | | |
| | | | |
| | | | |
| | | | |
| | | | |
| | | | |
| | | | |
| | | | |
| | | | |
| | | | |

MAKING GOALS

| QUANTITY | OBJECT | VARIATION | PRICE |
|----------|--------|-----------|-------|
|          |        |           |       |
|          |        |           |       |
|          |        |           |       |
|          |        |           |       |
|          |        |           |       |
|          |        |           |       |
|          |        |           |       |
|          |        |           |       |
|          |        |           |       |
|          |        |           |       |
|          |        |           |       |
|          |        |           |       |
|          |        |           |       |
|          |        |           |       |
|          |        |           |       |
|          |        |           |       |
|          |        |           |       |
|          |        |           |       |
|          |        |           |       |
|          |        |           |       |
|          |        |           |       |
|          |        |           |       |
|          |        |           |       |
|          |        |           |       |
|          |        |           |       |
|          |        |           |       |
|          |        |           |       |
|          |        |           |       |
|          |        |           |       |
|          |        |           |       |
|          |        |           |       |
|          |        |           |       |
|          |        |           |       |

SHOW:                          DATE:

| QUANTITY | OBJECT | VARIATION | PRICE |
|----------|--------|-----------|-------|
|          |        |           |       |
|          |        |           |       |
|          |        |           |       |
|          |        |           |       |
|          |        |           |       |
|          |        |           |       |
|          |        |           |       |
|          |        |           |       |
|          |        |           |       |
|          |        |           |       |
|          |        |           |       |
|          |        |           |       |
|          |        |           |       |
|          |        |           |       |
|          |        |           |       |
|          |        |           |       |
|          |        |           |       |
|          |        |           |       |
|          |        |           |       |
|          |        |           |       |
|          |        |           |       |
|          |        |           |       |
|          |        |           |       |
|          |        |           |       |
|          |        |           |       |
|          |        |           |       |
|          |        |           |       |
|          |        |           |       |
|          |        |           |       |
|          |        |           |       |
|          |        |           |       |
|          |        |           |       |
|          |        |           |       |
|          |        |           |       |
|          |        |           |       |

MAKING GOALS

SHOW:                                          DATE:

| QUANTITY | OBJECT | VARIATION | PRICE |
|----------|--------|-----------|-------|
|          |        |           |       |
|          |        |           |       |
|          |        |           |       |
|          |        |           |       |
|          |        |           |       |
|          |        |           |       |
|          |        |           |       |
|          |        |           |       |
|          |        |           |       |
|          |        |           |       |
|          |        |           |       |
|          |        |           |       |
|          |        |           |       |
|          |        |           |       |
|          |        |           |       |
|          |        |           |       |
|          |        |           |       |
|          |        |           |       |
|          |        |           |       |
|          |        |           |       |
|          |        |           |       |
|          |        |           |       |
|          |        |           |       |
|          |        |           |       |
|          |        |           |       |
|          |        |           |       |
|          |        |           |       |
|          |        |           |       |
|          |        |           |       |
|          |        |           |       |
|          |        |           |       |
|          |        |           |       |
|          |        |           |       |
|          |        |           |       |
|          |        |           |       |
|          |        |           |       |

SHOW:                                   DATE:

| QUANTITY | OBJECT | VARIATION | PRICE |
|---|---|---|---|
| | | | |
| | | | |
| | | | |
| | | | |
| | | | |
| | | | |
| | | | |
| | | | |
| | | | |
| | | | |
| | | | |
| | | | |
| | | | |
| | | | |
| | | | |
| | | | |
| | | | |
| | | | |
| | | | |
| | | | |
| | | | |
| | | | |
| | | | |
| | | | |
| | | | |
| | | | |
| | | | |
| | | | |
| | | | |
| | | | |
| | | | |
| | | | |
| | | | |
| | | | |

# GLAZE SECTION

# MATERIAL INVENTORY

| MATERIAL | $/LB | AMOUNT HELD | SUPPLIER |
|----------|------|-------------|----------|
|          |      |             |          |
|          |      |             |          |
|          |      |             |          |
|          |      |             |          |
|          |      |             |          |
|          |      |             |          |
|          |      |             |          |
|          |      |             |          |
|          |      |             |          |
|          |      |             |          |
|          |      |             |          |
|          |      |             |          |
|          |      |             |          |
|          |      |             |          |
|          |      |             |          |
|          |      |             |          |
|          |      |             |          |
|          |      |             |          |
|          |      |             |          |
|          |      |             |          |
|          |      |             |          |
|          |      |             |          |
|          |      |             |          |
|          |      |             |          |
|          |      |             |          |
|          |      |             |          |
|          |      |             |          |
|          |      |             |          |
|          |      |             |          |
|          |      |             |          |
|          |      |             |          |
|          |      |             |          |
|          |      |             |          |
|          |      |             |          |
|          |      |             |          |

| BATCH NUMBER | NOTES |
| --- | --- |
|  |  |
|  |  |
|  |  |
|  |  |
|  |  |
|  |  |
|  |  |
|  |  |
|  |  |
|  |  |
|  |  |
|  |  |
|  |  |
|  |  |
|  |  |
|  |  |
|  |  |
|  |  |
|  |  |
|  |  |
|  |  |
|  |  |
|  |  |
|  |  |
|  |  |
|  |  |
|  |  |
|  |  |
|  |  |
|  |  |
|  |  |
|  |  |
|  |  |
|  |  |
|  |  |
|  |  |
|  |  |
|  |  |
|  |  |
|  |  |

# MATERIAL INVENTORY

| MATERIAL | $/LB | AMOUNT HELD | SUPPLIER |
|---|---|---|---|
| | | | |
| | | | |
| | | | |
| | | | |
| | | | |
| | | | |
| | | | |
| | | | |
| | | | |
| | | | |
| | | | |
| | | | |
| | | | |
| | | | |
| | | | |
| | | | |
| | | | |
| | | | |
| | | | |
| | | | |
| | | | |
| | | | |
| | | | |
| | | | |
| | | | |
| | | | |
| | | | |
| | | | |
| | | | |
| | | | |
| | | | |
| | | | |
| | | | |
| | | | |
| | | | |

| BATCH NUMBER | NOTES |
|---|---|
|  |  |
|  |  |
|  |  |
|  |  |
|  |  |
|  |  |
|  |  |
|  |  |
|  |  |
|  |  |
|  |  |
|  |  |
|  |  |
|  |  |
|  |  |
|  |  |
|  |  |
|  |  |
|  |  |
|  |  |
|  |  |
|  |  |
|  |  |
|  |  |
|  |  |
|  |  |
|  |  |
|  |  |
|  |  |
|  |  |
|  |  |
|  |  |
|  |  |
|  |  |
|  |  |
|  |  |
|  |  |
|  |  |
|  |  |
|  |  |
|  |  |
|  |  |
|  |  |

# MATERIAL INVENTORY

| MATERIAL | $/LB | AMOUNT HELD | SUPPLIER |
|---|---|---|---|
|  |  |  |  |
|  |  |  |  |
|  |  |  |  |
|  |  |  |  |
|  |  |  |  |
|  |  |  |  |
|  |  |  |  |
|  |  |  |  |
|  |  |  |  |
|  |  |  |  |
|  |  |  |  |
|  |  |  |  |
|  |  |  |  |
|  |  |  |  |
|  |  |  |  |
|  |  |  |  |
|  |  |  |  |
|  |  |  |  |
|  |  |  |  |
|  |  |  |  |
|  |  |  |  |
|  |  |  |  |
|  |  |  |  |
|  |  |  |  |
|  |  |  |  |
|  |  |  |  |
|  |  |  |  |
|  |  |  |  |
|  |  |  |  |
|  |  |  |  |
|  |  |  |  |
|  |  |  |  |
|  |  |  |  |
|  |  |  |  |

| BATCH NUMBER | NOTES |
| --- | --- |
| | |
| | |
| | |
| | |
| | |
| | |
| | |
| | |
| | |
| | |
| | |
| | |
| | |
| | |
| | |
| | |
| | |
| | |
| | |
| | |
| | |
| | |
| | |
| | |
| | |
| | |
| | |
| | |
| | |
| | |
| | |
| | |
| | |
| | |
| | |
| | |
| | |
| | |

# CLAY TRACKER

| CLAY | TYPE | CONE | SUPPLIER | BATCH # |
|------|------|------|----------|---------|
|  |  |  |  |  |
|  |  |  |  |  |
|  |  |  |  |  |
|  |  |  |  |  |
|  |  |  |  |  |
|  |  |  |  |  |
|  |  |  |  |  |
|  |  |  |  |  |
|  |  |  |  |  |
|  |  |  |  |  |
|  |  |  |  |  |
|  |  |  |  |  |
|  |  |  |  |  |
|  |  |  |  |  |
|  |  |  |  |  |
|  |  |  |  |  |
|  |  |  |  |  |
|  |  |  |  |  |
|  |  |  |  |  |
|  |  |  |  |  |
|  |  |  |  |  |
|  |  |  |  |  |
|  |  |  |  |  |
|  |  |  |  |  |
|  |  |  |  |  |
|  |  |  |  |  |
|  |  |  |  |  |

HOW TO USE SHRINKAGE RATE TO MAKE A SPECIFIC SIZED FINAL PRODUCT
1. Given a shrinkage rate of 15%, subtract 15 from 100 = 85
2. Divide 100 by 85 to get the rate of increase = 1.176
3. Then you can multiply by your desired finished size to get the object's wet size: ex. 5in x 1.176 = 5.88in

| % RINK | LENGTH BONE DRY | LENGTH BISQUE | LENGTH AT GLAZE | NOTES |
|---|---|---|---|---|
| | | | | |
| | | | | |
| | | | | |
| | | | | |
| | | | | |
| | | | | |
| | | | | |
| | | | | |
| | | | | |
| | | | | |
| | | | | |
| | | | | |
| | | | | |
| | | | | |
| | | | | |
| | | | | |
| | | | | |
| | | | | |
| | | | | |
| | | | | |
| | | | | |
| | | | | |
| | | | | |
| | | | | |
| | | | | |
| | | | | |
| | | | | |
| | | | | |
| | | | | |
| | | | | |
| | | | | |
| | | | | |
| | | | | |

GLAZE RECIPE #

GLAZE NAME             TEMP          ATMOSPHERE

H₂O%        SP GRAVITY        MIX TIME        DIP TIME

| $/LB | INGREDIENT | % | | | | |
|---|---|---|---|---|---|---|
| | | | | | | |
| | | | | | | |
| | | | | | | |
| | | | | | | |
| | | | | | | |
| | | | | | | |
| | | | | | | |
| | | | | | | |
| | | | | | | |
| | | | | | | |
| | | | | | | |
| | | | | | | |
| | | | | | | |
| | | | | | | |
| | | | | | | |
| | | | | | | |
| | | | | | | |
| | | | | | | |
| | | | | | | |
| | | | | | | |
| | | | | | | |

APPLICATION NOTES:

GLAZE COMBO NOTES:

GLAZE RECIPE #

GLAZE NAME                    TEMP          ATMOSPHERE

H$_2$O%         SP GRAVITY      MIX TIME      DIP TIME

| $/LB | INGREDIENT | % | | | | |
|---|---|---|---|---|---|---|
| | | | | | | |
| | | | | | | |
| | | | | | | |
| | | | | | | |
| | | | | | | |
| | | | | | | |
| | | | | | | |
| | | | | | | |
| | | | | | | |
| | | | | | | |
| | | | | | | |
| | | | | | | |
| | | | | | | |
| | | | | | | |
| | | | | | | |
| | | | | | | |
| | | | | | | |
| | | | | | | |
| | | | | | | |
| | | | | | | |

APPLICATION NOTES:

GLAZE COMBO NOTES:

GLAZE RECIPE #

GLAZE NAME             TEMP          ATMOSPHERE

$H_2O$%        SP GRAVITY        MIX TIME        DIP TIME

| $/LB | INGREDIENT | % | | | | |
|---|---|---|---|---|---|---|
| | | | | | | |
| | | | | | | |
| | | | | | | |
| | | | | | | |
| | | | | | | |
| | | | | | | |
| | | | | | | |
| | | | | | | |
| | | | | | | |
| | | | | | | |
| | | | | | | |
| | | | | | | |
| | | | | | | |
| | | | | | | |
| | | | | | | |
| | | | | | | |
| | | | | | | |
| | | | | | | |
| | | | | | | |

APPLICATION NOTES:

GLAZE COMBO NOTES:

GLAZE RECIPE #

GLAZE NAME              TEMP        ATMOSPHERE

H₂O%        SP GRAVITY        MIX TIME       DIP TIME

| $/LB | INGREDIENT | % | | | | |
|---|---|---|---|---|---|---|
| | | | | | | |
| | | | | | | |
| | | | | | | |
| | | | | | | |
| | | | | | | |
| | | | | | | |
| | | | | | | |
| | | | | | | |
| | | | | | | |
| | | | | | | |
| | | | | | | |
| | | | | | | |
| | | | | | | |
| | | | | | | |
| | | | | | | |
| | | | | | | |
| | | | | | | |
| | | | | | | |
| | | | | | | |

APPLICATION NOTES:

GLAZE COMBO NOTES:

GLAZE RECIPE #

GLAZE NAME                   TEMP         ATMOSPHERE

H₂O%          SP GRAVITY        MIX TIME       DIP TIME

| $/LB | INGREDIENT | % | | | | |
|------|------------|---|---|---|---|---|
| | | | | | | |
| | | | | | | |
| | | | | | | |
| | | | | | | |
| | | | | | | |
| | | | | | | |
| | | | | | | |
| | | | | | | |
| | | | | | | |
| | | | | | | |
| | | | | | | |
| | | | | | | |
| | | | | | | |
| | | | | | | |
| | | | | | | |
| | | | | | | |
| | | | | | | |
| | | | | | | |
| | | | | | | |
| | | | | | | |

APPLICATION NOTES:

GLAZE COMBO NOTES:

GLAZE RECIPE #

GLAZE NAME                          TEMP          ATMOSPHERE

H$_2$O%              SP GRAVITY         MIX TIME         DIP TIME

| $/LB | INGREDIENT | % | | | | |
|------|------------|---|---|---|---|---|
|      |            |   |   |   |   |   |
|      |            |   |   |   |   |   |
|      |            |   |   |   |   |   |
|      |            |   |   |   |   |   |
|      |            |   |   |   |   |   |
|      |            |   |   |   |   |   |
|      |            |   |   |   |   |   |
|      |            |   |   |   |   |   |
|      |            |   |   |   |   |   |
|      |            |   |   |   |   |   |
|      |            |   |   |   |   |   |
|      |            |   |   |   |   |   |
|      |            |   |   |   |   |   |
|      |            |   |   |   |   |   |
|      |            |   |   |   |   |   |
|      |            |   |   |   |   |   |
|      |            |   |   |   |   |   |
|      |            |   |   |   |   |   |
|      |            |   |   |   |   |   |
|      |            |   |   |   |   |   |

APPLICATION NOTES:                    GLAZE COMBO NOTES:

GLAZE RECIPE #

GLAZE NAME                          TEMP              ATMOSPHERE

H$_2$O%              SP GRAVITY         MIX TIME          DIP TIME

| $/LB | INGREDIENT | % | | | | |
|------|-----------|---|---|---|---|---|
| | | | | | | |
| | | | | | | |
| | | | | | | |
| | | | | | | |
| | | | | | | |
| | | | | | | |
| | | | | | | |
| | | | | | | |
| | | | | | | |
| | | | | | | |
| | | | | | | |
| | | | | | | |
| | | | | | | |
| | | | | | | |
| | | | | | | |
| | | | | | | |
| | | | | | | |
| | | | | | | |
| | | | | | | |
| | | | | | | |

APPLICATION NOTES:                    GLAZE COMBO NOTES:

GLAZE RECIPE #

GLAZE NAME          TEMP          ATMOSPHERE

H$_2$O%        SP GRAVITY        MIX TIME        DIP TIME

| $/LB | INGREDIENT | % | | | | |
|---|---|---|---|---|---|---|
| | | | | | | |
| | | | | | | |
| | | | | | | |
| | | | | | | |
| | | | | | | |
| | | | | | | |
| | | | | | | |
| | | | | | | |
| | | | | | | |
| | | | | | | |
| | | | | | | |
| | | | | | | |
| | | | | | | |
| | | | | | | |
| | | | | | | |
| | | | | | | |
| | | | | | | |
| | | | | | | |
| | | | | | | |
| | | | | | | |

APPLICATION NOTES:

GLAZE COMBO NOTES:

GLAZE RECIPE #

GLAZE NAME                          TEMP            ATMOSPHERE

H₂O%              SP GRAVITY          MIX TIME        DIP TIME

| $/LB | INGREDIENT | % | | | | |
|------|------------|---|---|---|---|---|
| | | | | | | |
| | | | | | | |
| | | | | | | |
| | | | | | | |
| | | | | | | |
| | | | | | | |
| | | | | | | |
| | | | | | | |
| | | | | | | |
| | | | | | | |
| | | | | | | |
| | | | | | | |
| | | | | | | |
| | | | | | | |
| | | | | | | |
| | | | | | | |
| | | | | | | |
| | | | | | | |
| | | | | | | |
| | | | | | | |
| | | | | | | |
| | | | | | | |

APPLICATION NOTES:

GLAZE COMBO NOTES:

GLAZE RECIPE #

GLAZE NAME          TEMP          ATMOSPHERE

$H_2O\%$          SP GRAVITY          MIX TIME          DIP TIME

| $/LB | INGREDIENT | % | | | | |
|---|---|---|---|---|---|---|
| | | | | | | |
| | | | | | | |
| | | | | | | |
| | | | | | | |
| | | | | | | |
| | | | | | | |
| | | | | | | |
| | | | | | | |
| | | | | | | |
| | | | | | | |
| | | | | | | |
| | | | | | | |
| | | | | | | |
| | | | | | | |
| | | | | | | |
| | | | | | | |
| | | | | | | |
| | | | | | | |
| | | | | | | |
| | | | | | | |

APPLICATION NOTES:

GLAZE COMBO NOTES:

GLAZE RECIPE #

GLAZE NAME                         TEMP           ATMOSPHERE

H$_2$O%          SP GRAVITY          MIX TIME         DIP TIME

| $/LB | INGREDIENT | % | | | | |
|---|---|---|---|---|---|---|
| | | | | | | |
| | | | | | | |
| | | | | | | |
| | | | | | | |
| | | | | | | |
| | | | | | | |
| | | | | | | |
| | | | | | | |
| | | | | | | |
| | | | | | | |
| | | | | | | |
| | | | | | | |
| | | | | | | |
| | | | | | | |
| | | | | | | |
| | | | | | | |
| | | | | | | |
| | | | | | | |
| | | | | | | |
| | | | | | | |

APPLICATION NOTES:

GLAZE COMBO NOTES:

GLAZE RECIPE #

GLAZE NAME                    TEMP         ATMOSPHERE

H$_2$O%          SP GRAVITY        MIX TIME        DIP TIME

| $/LB | INGREDIENT | % | | | | |
|------|------------|---|---|---|---|---|
| | | | | | | |
| | | | | | | |
| | | | | | | |
| | | | | | | |
| | | | | | | |
| | | | | | | |
| | | | | | | |
| | | | | | | |
| | | | | | | |
| | | | | | | |
| | | | | | | |
| | | | | | | |
| | | | | | | |
| | | | | | | |
| | | | | | | |
| | | | | | | |
| | | | | | | |
| | | | | | | |
| | | | | | | |
| | | | | | | |

APPLICATION NOTES:                    GLAZE COMBO NOTES:

GLAZE RECIPE #

GLAZE NAME                            TEMP           ATMOSPHERE

$H_2O$%            SP GRAVITY         MIX TIME         DIP TIME

| $/LB | INGREDIENT | % | | | | |
|------|------------|---|---|---|---|---|
| | | | | | | |
| | | | | | | |
| | | | | | | |
| | | | | | | |
| | | | | | | |
| | | | | | | |
| | | | | | | |
| | | | | | | |
| | | | | | | |
| | | | | | | |
| | | | | | | |
| | | | | | | |
| | | | | | | |
| | | | | | | |
| | | | | | | |
| | | | | | | |
| | | | | | | |
| | | | | | | |
| | | | | | | |
| | | | | | | |

APPLICATION NOTES:

GLAZE COMBO NOTES:

GLAZE RECIPE #

GLAZE NAME                              TEMP              ATMOSPHERE

H$_2$O%                  SP GRAVITY        MIX TIME          DIP TIME

| $/LB | INGREDIENT | % | | | | |
|------|------------|---|---|---|---|---|
| | | | | | | |
| | | | | | | |
| | | | | | | |
| | | | | | | |
| | | | | | | |
| | | | | | | |
| | | | | | | |
| | | | | | | |
| | | | | | | |
| | | | | | | |
| | | | | | | |
| | | | | | | |
| | | | | | | |
| | | | | | | |
| | | | | | | |
| | | | | | | |
| | | | | | | |
| | | | | | | |
| | | | | | | |
| | | | | | | |
| | | | | | | |

APPLICATION NOTES:                      GLAZE COMBO NOTES:

GLAZE RECIPE #

GLAZE NAME                         TEMP              ATMOSPHERE

H$_2$O%              SP GRAVITY          MIX TIME          DIP TIME

| $/LB | INGREDIENT | % | | | | |
|---|---|---|---|---|---|---|
| | | | | | | |
| | | | | | | |
| | | | | | | |
| | | | | | | |
| | | | | | | |
| | | | | | | |
| | | | | | | |
| | | | | | | |
| | | | | | | |
| | | | | | | |
| | | | | | | |
| | | | | | | |
| | | | | | | |
| | | | | | | |
| | | | | | | |
| | | | | | | |
| | | | | | | |
| | | | | | | |
| | | | | | | |
| | | | | | | |

APPLICATION NOTES:

GLAZE COMBO NOTES:

GLAZE RECIPE #

GLAZE NAME                          TEMP            ATMOSPHERE

H₂O%                SP GRAVITY       MIX TIME        DIP TIME

| $/LB | INGREDIENT | % | | | | |
|------|------------|---|---|---|---|---|
| | | | | | | |
| | | | | | | |
| | | | | | | |
| | | | | | | |
| | | | | | | |
| | | | | | | |
| | | | | | | |
| | | | | | | |
| | | | | | | |
| | | | | | | |
| | | | | | | |
| | | | | | | |
| | | | | | | |
| | | | | | | |
| | | | | | | |
| | | | | | | |
| | | | | | | |
| | | | | | | |
| | | | | | | |
| | | | | | | |

APPLICATION NOTES:                  GLAZE COMBO NOTES:

GLAZE RECIPE #

GLAZE NAME                    TEMP              ATMOSPHERE

H$_2$O%            SP GRAVITY           MIX TIME           DIP TIME

| $/LB | INGREDIENT | % | | | | |
|------|------------|---|---|---|---|---|
|      |            |   |   |   |   |   |
|      |            |   |   |   |   |   |
|      |            |   |   |   |   |   |
|      |            |   |   |   |   |   |
|      |            |   |   |   |   |   |
|      |            |   |   |   |   |   |
|      |            |   |   |   |   |   |
|      |            |   |   |   |   |   |
|      |            |   |   |   |   |   |
|      |            |   |   |   |   |   |
|      |            |   |   |   |   |   |
|      |            |   |   |   |   |   |
|      |            |   |   |   |   |   |
|      |            |   |   |   |   |   |
|      |            |   |   |   |   |   |
|      |            |   |   |   |   |   |
|      |            |   |   |   |   |   |
|      |            |   |   |   |   |   |
|      |            |   |   |   |   |   |
|      |            |   |   |   |   |   |

APPLICATION NOTES:                    GLAZE COMBO NOTES:

GLAZE RECIPE #

GLAZE NAME                          TEMP            ATMOSPHERE

$H_2O$%              SP GRAVITY              MIX TIME        DIP TIME

| $/LB | INGREDIENT | % | | | | |
|------|-----------|---|---|---|---|---|
| | | | | | | |
| | | | | | | |
| | | | | | | |
| | | | | | | |
| | | | | | | |
| | | | | | | |
| | | | | | | |
| | | | | | | |
| | | | | | | |
| | | | | | | |
| | | | | | | |
| | | | | | | |
| | | | | | | |
| | | | | | | |
| | | | | | | |
| | | | | | | |
| | | | | | | |
| | | | | | | |
| | | | | | | |
| | | | | | | |

APPLICATION NOTES:

GLAZE COMBO NOTES:

GLAZE RECIPE #

GLAZE NAME                          TEMP              ATMOSPHERE

H$_2$O%              SP GRAVITY            MIX TIME           DIP TIME

| $/LB | INGREDIENT | % | | | | |
|------|------------|---|---|---|---|---|
| | | | | | | |
| | | | | | | |
| | | | | | | |
| | | | | | | |
| | | | | | | |
| | | | | | | |
| | | | | | | |
| | | | | | | |
| | | | | | | |
| | | | | | | |
| | | | | | | |
| | | | | | | |
| | | | | | | |
| | | | | | | |
| | | | | | | |
| | | | | | | |
| | | | | | | |
| | | | | | | |
| | | | | | | |
| | | | | | | |

APPLICATION NOTES:                        GLAZE COMBO NOTES:

GLAZE RECIPE #

GLAZE NAME                          TEMP                    ATMOSPHERE

H$_2$O%                    SP GRAVITY              MIX TIME                DIP TIME

| $/LB | INGREDIENT | % | | | | |
|---|---|---|---|---|---|---|
| | | | | | | |
| | | | | | | |
| | | | | | | |
| | | | | | | |
| | | | | | | |
| | | | | | | |
| | | | | | | |
| | | | | | | |
| | | | | | | |
| | | | | | | |
| | | | | | | |
| | | | | | | |
| | | | | | | |
| | | | | | | |
| | | | | | | |
| | | | | | | |
| | | | | | | |
| | | | | | | |
| | | | | | | |
| | | | | | | |

APPLICATION NOTES:

GLAZE COMBO NOTES:

GLAZE RECIPE #

GLAZE NAME                                         TEMP                 ATMOSPHERE

$H_2O$%                     SP GRAVITY                 MIX TIME                 DIP TIME

| $/LB | INGREDIENT | % | | | | |
|------|------------|---|---|---|---|---|
|      |            |   |   |   |   |   |
|      |            |   |   |   |   |   |
|      |            |   |   |   |   |   |
|      |            |   |   |   |   |   |
|      |            |   |   |   |   |   |
|      |            |   |   |   |   |   |
|      |            |   |   |   |   |   |
|      |            |   |   |   |   |   |
|      |            |   |   |   |   |   |
|      |            |   |   |   |   |   |
|      |            |   |   |   |   |   |
|      |            |   |   |   |   |   |
|      |            |   |   |   |   |   |
|      |            |   |   |   |   |   |
|      |            |   |   |   |   |   |
|      |            |   |   |   |   |   |
|      |            |   |   |   |   |   |
|      |            |   |   |   |   |   |
|      |            |   |   |   |   |   |
|      |            |   |   |   |   |   |

APPLICATION NOTES:

GLAZE COMBO NOTES:

GLAZE RECIPE #

GLAZE NAME                                             TEMP                ATMOSPHERE

$H_2O$%                 SP GRAVITY            MIX TIME            DIP TIME

| $/LB | INGREDIENT | % | | | | |
|---|---|---|---|---|---|---|
| | | | | | | |
| | | | | | | |
| | | | | | | |
| | | | | | | |
| | | | | | | |
| | | | | | | |
| | | | | | | |
| | | | | | | |
| | | | | | | |
| | | | | | | |
| | | | | | | |
| | | | | | | |
| | | | | | | |
| | | | | | | |
| | | | | | | |
| | | | | | | |
| | | | | | | |
| | | | | | | |
| | | | | | | |
| | | | | | | |
| | | | | | | |

APPLICATION NOTES:

GLAZE COMBO NOTES:

GLAZE RECIPE #

GLAZE NAME                    TEMP          ATMOSPHERE

H$_2$O%        SP GRAVITY       MIX TIME      DIP TIME

| $/LB | INGREDIENT | % | | | | |
|---|---|---|---|---|---|---|
| | | | | | | |
| | | | | | | |
| | | | | | | |
| | | | | | | |
| | | | | | | |
| | | | | | | |
| | | | | | | |
| | | | | | | |
| | | | | | | |
| | | | | | | |
| | | | | | | |
| | | | | | | |
| | | | | | | |
| | | | | | | |
| | | | | | | |
| | | | | | | |
| | | | | | | |
| | | | | | | |
| | | | | | | |
| | | | | | | |
| | | | | | | |

APPLICATION NOTES:

GLAZE COMBO NOTES:

GLAZE RECIPE #

GLAZE NAME                    TEMP          ATMOSPHERE

H₂O%              SP GRAVITY           MIX TIME          DIP TIME

| $/LB | INGREDIENT | % | | | | |
|------|------------|---|---|---|---|---|
|      |            |   |   |   |   |   |
|      |            |   |   |   |   |   |
|      |            |   |   |   |   |   |
|      |            |   |   |   |   |   |
|      |            |   |   |   |   |   |
|      |            |   |   |   |   |   |
|      |            |   |   |   |   |   |
|      |            |   |   |   |   |   |
|      |            |   |   |   |   |   |
|      |            |   |   |   |   |   |
|      |            |   |   |   |   |   |
|      |            |   |   |   |   |   |
|      |            |   |   |   |   |   |
|      |            |   |   |   |   |   |
|      |            |   |   |   |   |   |
|      |            |   |   |   |   |   |
|      |            |   |   |   |   |   |
|      |            |   |   |   |   |   |
|      |            |   |   |   |   |   |
|      |            |   |   |   |   |   |

APPLICATION NOTES:                    GLAZE COMBO NOTES:

GLAZE RECIPE #

GLAZE NAME                          TEMP              ATMOSPHERE

H₂O%              SP GRAVITY        MIX TIME          DIP TIME

| $/LB | INGREDIENT | % | | | | |
|------|------------|---|---|---|---|---|
|      |            |   |   |   |   |   |
|      |            |   |   |   |   |   |
|      |            |   |   |   |   |   |
|      |            |   |   |   |   |   |
|      |            |   |   |   |   |   |
|      |            |   |   |   |   |   |
|      |            |   |   |   |   |   |
|      |            |   |   |   |   |   |
|      |            |   |   |   |   |   |
|      |            |   |   |   |   |   |
|      |            |   |   |   |   |   |
|      |            |   |   |   |   |   |
|      |            |   |   |   |   |   |
|      |            |   |   |   |   |   |
|      |            |   |   |   |   |   |
|      |            |   |   |   |   |   |
|      |            |   |   |   |   |   |
|      |            |   |   |   |   |   |
|      |            |   |   |   |   |   |
|      |            |   |   |   |   |   |
|      |            |   |   |   |   |   |

APPLICATION NOTES:                              GLAZE COMBO NOTES:

GLAZE RECIPE #

GLAZE NAME                TEMP           ATMOSPHERE

H$_2$O%        SP GRAVITY        MIX TIME       DIP TIME

| $/LB | INGREDIENT | % | | | | |
|---|---|---|---|---|---|---|
| | | | | | | |
| | | | | | | |
| | | | | | | |
| | | | | | | |
| | | | | | | |
| | | | | | | |
| | | | | | | |
| | | | | | | |
| | | | | | | |
| | | | | | | |
| | | | | | | |
| | | | | | | |
| | | | | | | |
| | | | | | | |
| | | | | | | |
| | | | | | | |
| | | | | | | |
| | | | | | | |
| | | | | | | |
| | | | | | | |
| | | | | | | |

APPLICATION NOTES:

GLAZE COMBO NOTES:

GLAZE RECIPE #

GLAZE NAME       TEMP    ATMOSPHERE

H₂O%    SP GRAVITY    MIX TIME   DIP TIME

| $/LB | INGREDIENT | % | | | | |
|---|---|---|---|---|---|---|
| | | | | | | |
| | | | | | | |
| | | | | | | |
| | | | | | | |
| | | | | | | |
| | | | | | | |
| | | | | | | |
| | | | | | | |
| | | | | | | |
| | | | | | | |
| | | | | | | |
| | | | | | | |
| | | | | | | |
| | | | | | | |
| | | | | | | |
| | | | | | | |
| | | | | | | |
| | | | | | | |
| | | | | | | |
| | | | | | | |

APPLICATION NOTES:

GLAZE COMBO NOTES:

GLAZE RECIPE #

GLAZE NAME                              TEMP            ATMOSPHERE

H₂O%                  SP GRAVITY        MIX TIME        DIP TIME

| $/LB | INGREDIENT | % | | | | |
|------|-----------|---|---|---|---|---|
|      |           |   |   |   |   |   |
|      |           |   |   |   |   |   |
|      |           |   |   |   |   |   |
|      |           |   |   |   |   |   |
|      |           |   |   |   |   |   |
|      |           |   |   |   |   |   |
|      |           |   |   |   |   |   |
|      |           |   |   |   |   |   |
|      |           |   |   |   |   |   |
|      |           |   |   |   |   |   |
|      |           |   |   |   |   |   |
|      |           |   |   |   |   |   |
|      |           |   |   |   |   |   |
|      |           |   |   |   |   |   |
|      |           |   |   |   |   |   |
|      |           |   |   |   |   |   |
|      |           |   |   |   |   |   |
|      |           |   |   |   |   |   |
|      |           |   |   |   |   |   |
|      |           |   |   |   |   |   |
|      |           |   |   |   |   |   |

APPLICATION NOTES:                      GLAZE COMBO NOTES:

GLAZE RECIPE #

GLAZE NAME                    TEMP         ATMOSPHERE

H₂O%       SP GRAVITY       MIX TIME      DIP TIME

| $/LB | INGREDIENT | % | | | | |
|------|------------|---|---|---|---|---|
|      |            |   |   |   |   |   |
|      |            |   |   |   |   |   |
|      |            |   |   |   |   |   |
|      |            |   |   |   |   |   |
|      |            |   |   |   |   |   |
|      |            |   |   |   |   |   |
|      |            |   |   |   |   |   |
|      |            |   |   |   |   |   |
|      |            |   |   |   |   |   |
|      |            |   |   |   |   |   |
|      |            |   |   |   |   |   |
|      |            |   |   |   |   |   |
|      |            |   |   |   |   |   |
|      |            |   |   |   |   |   |
|      |            |   |   |   |   |   |
|      |            |   |   |   |   |   |
|      |            |   |   |   |   |   |
|      |            |   |   |   |   |   |
|      |            |   |   |   |   |   |
|      |            |   |   |   |   |   |

APPLICATION NOTES:

GLAZE COMBO NOTES:

GLAZE RECIPE #

GLAZE NAME                          TEMP              ATMOSPHERE

H$_2$O%                  SP GRAVITY        MIX TIME          DIP TIME

| $/LB | INGREDIENT | % | | | | |
|---|---|---|---|---|---|---|
| | | | | | | |
| | | | | | | |
| | | | | | | |
| | | | | | | |
| | | | | | | |
| | | | | | | |
| | | | | | | |
| | | | | | | |
| | | | | | | |
| | | | | | | |
| | | | | | | |
| | | | | | | |
| | | | | | | |
| | | | | | | |
| | | | | | | |
| | | | | | | |
| | | | | | | |
| | | | | | | |
| | | | | | | |
| | | | | | | |
| | | | | | | |

APPLICATION NOTES:

GLAZE COMBO NOTES:

GLAZE RECIPE #

GLAZE NAME                          TEMP           ATMOSPHERE

$H_2O$%               SP GRAVITY         MIX TIME        DIP TIME

| $/LB | INGREDIENT | % | | | | |
|------|------------|---|---|---|---|---|
| | | | | | | |
| | | | | | | |
| | | | | | | |
| | | | | | | |
| | | | | | | |
| | | | | | | |
| | | | | | | |
| | | | | | | |
| | | | | | | |
| | | | | | | |
| | | | | | | |
| | | | | | | |
| | | | | | | |
| | | | | | | |
| | | | | | | |
| | | | | | | |
| | | | | | | |
| | | | | | | |
| | | | | | | |
| | | | | | | |

APPLICATION NOTES:

GLAZE COMBO NOTES:

GLAZE RECIPE #

GLAZE NAME                                    TEMP                ATMOSPHERE

H$_2$O%                  SP GRAVITY              MIX TIME           DIP TIME

| $/LB | INGREDIENT | % | | | | |
|------|-----------|---|---|---|---|---|
| | | | | | | |
| | | | | | | |
| | | | | | | |
| | | | | | | |
| | | | | | | |
| | | | | | | |
| | | | | | | |
| | | | | | | |
| | | | | | | |
| | | | | | | |
| | | | | | | |
| | | | | | | |
| | | | | | | |
| | | | | | | |
| | | | | | | |
| | | | | | | |
| | | | | | | |
| | | | | | | |
| | | | | | | |
| | | | | | | |

APPLICATION NOTES:

GLAZE COMBO NOTES:

GLAZE RECIPE #

GLAZE NAME                    TEMP            ATMOSPHERE

H₂O%            SP GRAVITY          MIX TIME        DIP TIME

| $/LB | INGREDIENT | % | | | | |
|------|-----------|---|---|---|---|---|
| | | | | | | |
| | | | | | | |
| | | | | | | |
| | | | | | | |
| | | | | | | |
| | | | | | | |
| | | | | | | |
| | | | | | | |
| | | | | | | |
| | | | | | | |
| | | | | | | |
| | | | | | | |
| | | | | | | |
| | | | | | | |
| | | | | | | |
| | | | | | | |
| | | | | | | |
| | | | | | | |
| | | | | | | |

APPLICATION NOTES:

GLAZE COMBO NOTES:

GLAZE RECIPE #

GLAZE NAME                     TEMP              ATMOSPHERE

H$_2$O%              SP GRAVITY            MIX TIME          DIP TIME

| $/LB | INGREDIENT | % | | | | |
|---|---|---|---|---|---|---|
| | | | | | | |
| | | | | | | |
| | | | | | | |
| | | | | | | |
| | | | | | | |
| | | | | | | |
| | | | | | | |
| | | | | | | |
| | | | | | | |
| | | | | | | |
| | | | | | | |
| | | | | | | |
| | | | | | | |
| | | | | | | |
| | | | | | | |
| | | | | | | |
| | | | | | | |
| | | | | | | |
| | | | | | | |
| | | | | | | |

APPLICATION NOTES:                          GLAZE COMBO NOTES:

GLAZE RECIPE #

GLAZE NAME                          TEMP              ATMOSPHERE

H$_2$O%              SP GRAVITY              MIX TIME          DIP TIME

| $/LB | INGREDIENT | % | | | | |
|---|---|---|---|---|---|---|
| | | | | | | |
| | | | | | | |
| | | | | | | |
| | | | | | | |
| | | | | | | |
| | | | | | | |
| | | | | | | |
| | | | | | | |
| | | | | | | |
| | | | | | | |
| | | | | | | |
| | | | | | | |
| | | | | | | |
| | | | | | | |
| | | | | | | |
| | | | | | | |
| | | | | | | |
| | | | | | | |
| | | | | | | |

APPLICATION NOTES:

GLAZE COMBO NOTES:

GLAZE RECIPE #

GLAZE NAME                    TEMP          ATMOSPHERE

H$_2$O%            SP GRAVITY        MIX TIME        DIP TIME

| $/LB | INGREDIENT | % | | | | |
|---|---|---|---|---|---|---|
| | | | | | | |
| | | | | | | |
| | | | | | | |
| | | | | | | |
| | | | | | | |
| | | | | | | |
| | | | | | | |
| | | | | | | |
| | | | | | | |
| | | | | | | |
| | | | | | | |
| | | | | | | |
| | | | | | | |
| | | | | | | |
| | | | | | | |
| | | | | | | |
| | | | | | | |
| | | | | | | |
| | | | | | | |
| | | | | | | |
| | | | | | | |

APPLICATION NOTES:                    GLAZE COMBO NOTES:

GLAZE RECIPE #

GLAZE NAME                                    TEMP                ATMOSPHERE

H₂O%                        SP GRAVITY                MIX TIME            DIP TIME

| $/LB | INGREDIENT | % | | | | |
|------|-----------|---|---|---|---|---|
| | | | | | | |
| | | | | | | |
| | | | | | | |
| | | | | | | |
| | | | | | | |
| | | | | | | |
| | | | | | | |
| | | | | | | |
| | | | | | | |
| | | | | | | |
| | | | | | | |
| | | | | | | |
| | | | | | | |
| | | | | | | |
| | | | | | | |
| | | | | | | |
| | | | | | | |
| | | | | | | |
| | | | | | | |
| | | | | | | |

APPLICATION NOTES:

GLAZE COMBO NOTES:

GLAZE RECIPE #

GLAZE NAME                          TEMP                ATMOSPHERE

$H_2O$%                SP GRAVITY           MIX TIME            DIP TIME

| $/LB | INGREDIENT | % | | | | |
|---|---|---|---|---|---|---|
| | | | | | | |
| | | | | | | |
| | | | | | | |
| | | | | | | |
| | | | | | | |
| | | | | | | |
| | | | | | | |
| | | | | | | |
| | | | | | | |
| | | | | | | |
| | | | | | | |
| | | | | | | |
| | | | | | | |
| | | | | | | |
| | | | | | | |
| | | | | | | |
| | | | | | | |
| | | | | | | |
| | | | | | | |
| | | | | | | |
| | | | | | | |
| | | | | | | |

APPLICATION NOTES:

GLAZE COMBO NOTES:

GLAZE RECIPE #

GLAZE NAME                          TEMP              ATMOSPHERE

H$_2$O%              SP GRAVITY              MIX TIME              DIP TIME

| $/LB | INGREDIENT | % | | | | |
|------|-----------|---|---|---|---|---|
| | | | | | | |
| | | | | | | |
| | | | | | | |
| | | | | | | |
| | | | | | | |
| | | | | | | |
| | | | | | | |
| | | | | | | |
| | | | | | | |
| | | | | | | |
| | | | | | | |
| | | | | | | |
| | | | | | | |
| | | | | | | |
| | | | | | | |
| | | | | | | |
| | | | | | | |
| | | | | | | |
| | | | | | | |

APPLICATION NOTES:

GLAZE COMBO NOTES:

GLAZE RECIPE #

GLAZE NAME                          TEMP              ATMOSPHERE

H₂O%                 SP GRAVITY         MIX TIME          DIP TIME

| $/LB | INGREDIENT | % | | | | |
|------|------------|---|---|---|---|---|
|      |            |   |   |   |   |   |
|      |            |   |   |   |   |   |
|      |            |   |   |   |   |   |
|      |            |   |   |   |   |   |
|      |            |   |   |   |   |   |
|      |            |   |   |   |   |   |
|      |            |   |   |   |   |   |
|      |            |   |   |   |   |   |
|      |            |   |   |   |   |   |
|      |            |   |   |   |   |   |
|      |            |   |   |   |   |   |
|      |            |   |   |   |   |   |
|      |            |   |   |   |   |   |
|      |            |   |   |   |   |   |
|      |            |   |   |   |   |   |
|      |            |   |   |   |   |   |
|      |            |   |   |   |   |   |
|      |            |   |   |   |   |   |
|      |            |   |   |   |   |   |
|      |            |   |   |   |   |   |

APPLICATION NOTES:                  GLAZE COMBO NOTES:

GLAZE LAYERING

| # | GLAZE | COATS |
|---|-------|-------|
| 1 | | |
| 2 | | |
| 3 | | |
| 4 | | |
| 5 | | |

CONE:

APPLICATION DETAILS:

NOTES:

| # | GLAZE | COATS |
|---|-------|-------|
| 1 | | |
| 2 | | |
| 3 | | |
| 4 | | |
| 5 | | |

CONE:

APPLICATION DETAILS:

NOTES:

| # | GLAZE | COATS |
|---|-------|-------|
| 1 | | |
| 2 | | |
| 3 | | |
| 4 | | |
| 5 | | |

CONE:

APPLICATION DETAILS:

NOTES:

| # | GLAZE | COATS |
|---|-------|-------|
| 1 | | |
| 2 | | |
| 3 | | |
| 4 | | |
| 5 | | |

CONE:

APPLICATION DETAILS:

NOTES:

| # | GLAZE | COATS |
|---|-------|-------|
| 1 | | |
| 2 | | |
| 3 | | |
| 4 | | |
| 5 | | |

CONE:

APPLICATION DETAILS:

NOTES:

| # | GLAZE | COATS |
|---|-------|-------|
| 1 | | |
| 2 | | |
| 3 | | |
| 4 | | |
| 5 | | |

CONE:

APPLICATION DETAILS:

NOTES:

| # | GLAZE | COATS |
|---|-------|-------|
| 1 | | |
| 2 | | |
| 3 | | |
| 4 | | |
| 5 | | |

CONE:

APPLICATION DETAILS:

NOTES:

| # | GLAZE | COATS |
|---|-------|-------|
| 1 | | |
| 2 | | |
| 3 | | |
| 4 | | |
| 5 | | |

CONE:

APPLICATION DETAILS:

NOTES:

GLAZE LAYERING

| # | GLAZE | COATS |
|---|-------|-------|
| 1 | | |
| 2 | | |
| 3 | | |
| 4 | | |
| 5 | | |

CONE:

APPLICATION DETAILS:

NOTES:

| # | GLAZE | COATS |
|---|-------|-------|
| 1 | | |
| 2 | | |
| 3 | | |
| 4 | | |
| 5 | | |

CONE:

APPLICATION DETAILS:

NOTES:

| # | GLAZE | COATS |
|---|-------|-------|
| 1 | | |
| 2 | | |
| 3 | | |
| 4 | | |
| 5 | | |

CONE:

APPLICATION DETAILS:

NOTES:

| # | GLAZE | COATS |
|---|-------|-------|
| 1 | | |
| 2 | | |
| 3 | | |
| 4 | | |
| 5 | | |

CONE:

APPLICATION DETAILS:

NOTES:

| # | GLAZE | COATS |
|---|-------|-------|
| 1 | | |
| 2 | | |
| 3 | | |
| 4 | | |
| 5 | | |

CONE:

APPLICATION DETAILS:

NOTES:

| # | GLAZE | COATS |
|---|-------|-------|
| 1 | | |
| 2 | | |
| 3 | | |
| 4 | | |
| 5 | | |

CONE:

APPLICATION DETAILS:

NOTES:

| # | GLAZE | COATS |
|---|-------|-------|
| 1 | | |
| 2 | | |
| 3 | | |
| 4 | | |
| 5 | | |

CONE:

APPLICATION DETAILS:

NOTES:

| # | GLAZE | COATS |
|---|-------|-------|
| 1 | | |
| 2 | | |
| 3 | | |
| 4 | | |
| 5 | | |

CONE:

APPLICATION DETAILS:

NOTES:

GLAZE LAYERING

| # | GLAZE | COATS |
|---|-------|-------|
| 1 |       |       |
| 2 |       |       |
| 3 |       |       |
| 4 |       |       |
| 5 |       |       |

CONE:

APPLICATION DETAILS:

NOTES:

| # | GLAZE | COATS |
|---|-------|-------|
| 1 |       |       |
| 2 |       |       |
| 3 |       |       |
| 4 |       |       |
| 5 |       |       |

CONE:

APPLICATION DETAILS:

NOTES:

| # | GLAZE | COATS |
|---|-------|-------|
| 1 |       |       |
| 2 |       |       |
| 3 |       |       |
| 4 |       |       |
| 5 |       |       |

CONE:

APPLICATION DETAILS:

NOTES:

| # | GLAZE | COATS |
|---|-------|-------|
| 1 |       |       |
| 2 |       |       |
| 3 |       |       |
| 4 |       |       |
| 5 |       |       |

CONE:

APPLICATION DETAILS:

NOTES:

| # | GLAZE | COATS |
|---|-------|-------|
| 1 | | |
| 2 | | |
| 3 | | |
| 4 | | |
| 5 | | |

CONE:

APPLICATION DETAILS:

NOTES:

| # | GLAZE | COATS |
|---|-------|-------|
| 1 | | |
| 2 | | |
| 3 | | |
| 4 | | |
| 5 | | |

CONE:

APPLICATION DETAILS:

NOTES:

| # | GLAZE | COATS |
|---|-------|-------|
| 1 | | |
| 2 | | |
| 3 | | |
| 4 | | |
| 5 | | |

CONE:

APPLICATION DETAILS:

NOTES:

| # | GLAZE | COATS |
|---|-------|-------|
| 1 | | |
| 2 | | |
| 3 | | |
| 4 | | |
| 5 | | |

CONE:

APPLICATION DETAILS:

NOTES:

# GLAZE LAYERING

| # | GLAZE | COATS |
|---|-------|-------|
| 1 | | |
| 2 | | |
| 3 | | |
| 4 | | |
| 5 | | |

CONE:

APPLICATION DETAILS:

NOTES:

| # | GLAZE | COATS |
|---|-------|-------|
| 1 | | |
| 2 | | |
| 3 | | |
| 4 | | |
| 5 | | |

CONE:

APPLICATION DETAILS:

NOTES:

| # | GLAZE | COATS |
|---|-------|-------|
| 1 | | |
| 2 | | |
| 3 | | |
| 4 | | |
| 5 | | |

CONE:

APPLICATION DETAILS:

NOTES:

| # | GLAZE | COATS |
|---|-------|-------|
| 1 | | |
| 2 | | |
| 3 | | |
| 4 | | |
| 5 | | |

CONE:

APPLICATION DETAILS:

NOTES:

| # | GLAZE | COATS |
|---|-------|-------|
| 1 | | |
| 2 | | |
| 3 | | |
| 4 | | |
| 5 | | |

CONE:

APPLICATION DETAILS:

NOTES:

| # | GLAZE | COATS |
|---|-------|-------|
| 1 | | |
| 2 | | |
| 3 | | |
| 4 | | |
| 5 | | |

CONE:

APPLICATION DETAILS:

NOTES:

| # | GLAZE | COATS |
|---|-------|-------|
| 1 | | |
| 2 | | |
| 3 | | |
| 4 | | |
| 5 | | |

CONE:

APPLICATION DETAILS:

NOTES:

| # | GLAZE | COATS |
|---|-------|-------|
| 1 | | |
| 2 | | |
| 3 | | |
| 4 | | |
| 5 | | |

CONE:

APPLICATION DETAILS:

NOTES:

GLAZE LAYERING

| # | GLAZE | COATS |
|---|-------|-------|
| 1 | | |
| 2 | | |
| 3 | | |
| 4 | | |
| 5 | | |

CONE:

APPLICATION DETAILS:

NOTES:

| # | GLAZE | COATS |
|---|-------|-------|
| 1 | | |
| 2 | | |
| 3 | | |
| 4 | | |
| 5 | | |

CONE:

APPLICATION DETAILS:

NOTES:

| # | GLAZE | COATS |
|---|-------|-------|
| 1 | | |
| 2 | | |
| 3 | | |
| 4 | | |
| 5 | | |

CONE:

APPLICATION DETAILS:

NOTES:

| # | GLAZE | COATS |
|---|-------|-------|
| 1 | | |
| 2 | | |
| 3 | | |
| 4 | | |
| 5 | | |

CONE:

APPLICATION DETAILS:

NOTES:

| # | GLAZE | COATS |
|---|-------|-------|
| 1 | | |
| 2 | | |
| 3 | | |
| 4 | | |
| 5 | | |

CONE:

APPLICATION DETAILS:

NOTES:

| # | GLAZE | COATS |
|---|-------|-------|
| 1 | | |
| 2 | | |
| 3 | | |
| 4 | | |
| 5 | | |

CONE:

APPLICATION DETAILS:

NOTES:

| # | GLAZE | COATS |
|---|-------|-------|
| 1 | | |
| 2 | | |
| 3 | | |
| 4 | | |
| 5 | | |

CONE:

APPLICATION DETAILS:

NOTES:

| # | GLAZE | COATS |
|---|-------|-------|
| 1 | | |
| 2 | | |
| 3 | | |
| 4 | | |
| 5 | | |

CONE:

APPLICATION DETAILS:

NOTES:

GLAZE LAYERING

| # | GLAZE | COATS |
|---|-------|-------|
| 1 |       |       |
| 2 |       |       |
| 3 |       |       |
| 4 |       |       |
| 5 |       |       |

CONE:

APPLICATION DETAILS:

NOTES:

| # | GLAZE | COATS |
|---|-------|-------|
| 1 |       |       |
| 2 |       |       |
| 3 |       |       |
| 4 |       |       |
| 5 |       |       |

CONE:

APPLICATION DETAILS:

NOTES:

| # | GLAZE | COATS |
|---|-------|-------|
| 1 |       |       |
| 2 |       |       |
| 3 |       |       |
| 4 |       |       |
| 5 |       |       |

CONE:

APPLICATION DETAILS:

NOTES:

| # | GLAZE | COATS |
|---|-------|-------|
| 1 |       |       |
| 2 |       |       |
| 3 |       |       |
| 4 |       |       |
| 5 |       |       |

CONE:

APPLICATION DETAILS:

NOTES:

| # | GLAZE | COATS |
|---|-------|-------|
| 1 | | |
| 2 | | |
| 3 | | |
| 4 | | |
| 5 | | |

CONE:

APPLICATION DETAILS:

NOTES:

| # | GLAZE | COATS |
|---|-------|-------|
| 1 | | |
| 2 | | |
| 3 | | |
| 4 | | |
| 5 | | |

CONE:

APPLICATION DETAILS:

NOTES:

| # | GLAZE | COATS |
|---|-------|-------|
| 1 | | |
| 2 | | |
| 3 | | |
| 4 | | |
| 5 | | |

CONE:

APPLICATION DETAILS:

NOTES:

| # | GLAZE | COATS |
|---|-------|-------|
| 1 | | |
| 2 | | |
| 3 | | |
| 4 | | |
| 5 | | |

CONE:

APPLICATION DETAILS:

NOTES:

GLAZE LAYERING

| # | GLAZE | COATS |
|---|-------|-------|
| 1 | | |
| 2 | | |
| 3 | | |
| 4 | | |
| 5 | | |

CONE:

APPLICATION DETAILS:

NOTES:

| # | GLAZE | COATS |
|---|-------|-------|
| 1 | | |
| 2 | | |
| 3 | | |
| 4 | | |
| 5 | | |

CONE:

APPLICATION DETAILS:

NOTES:

| # | GLAZE | COATS |
|---|-------|-------|
| 1 | | |
| 2 | | |
| 3 | | |
| 4 | | |
| 5 | | |

CONE:

APPLICATION DETAILS:

NOTES:

| # | GLAZE | COATS |
|---|-------|-------|
| 1 | | |
| 2 | | |
| 3 | | |
| 4 | | |
| 5 | | |

CONE:

APPLICATION DETAILS:

NOTES:

| # | GLAZE | COATS |
|---|-------|-------|
| 1 | | |
| 2 | | |
| 3 | | |
| 4 | | |
| 5 | | |

CONE:

APPLICATION DETAILS:

NOTES:

| # | GLAZE | COATS |
|---|-------|-------|
| 1 | | |
| 2 | | |
| 3 | | |
| 4 | | |
| 5 | | |

CONE:

APPLICATION DETAILS:

NOTES:

| # | GLAZE | COATS |
|---|-------|-------|
| 1 | | |
| 2 | | |
| 3 | | |
| 4 | | |
| 5 | | |

CONE:

APPLICATION DETAILS:

NOTES:

| # | GLAZE | COATS |
|---|-------|-------|
| 1 | | |
| 2 | | |
| 3 | | |
| 4 | | |
| 5 | | |

CONE:

APPLICATION DETAILS:

NOTES:

# GLAZE LAYERING

| # | GLAZE | COATS |
|---|-------|-------|
| 1 | | |
| 2 | | |
| 3 | | |
| 4 | | |
| 5 | | |

CONE:

APPLICATION DETAILS:

NOTES:

| # | GLAZE | COATS |
|---|-------|-------|
| 1 | | |
| 2 | | |
| 3 | | |
| 4 | | |
| 5 | | |

CONE:

APPLICATION DETAILS:

NOTES:

| # | GLAZE | COATS |
|---|-------|-------|
| 1 | | |
| 2 | | |
| 3 | | |
| 4 | | |
| 5 | | |

CONE:

APPLICATION DETAILS:

NOTES:

| # | GLAZE | COATS |
|---|-------|-------|
| 1 | | |
| 2 | | |
| 3 | | |
| 4 | | |
| 5 | | |

CONE:

APPLICATION DETAILS:

NOTES:

| # | GLAZE | COATS |
|---|-------|-------|
| 1 | | |
| 2 | | |
| 3 | | |
| 4 | | |
| 5 | | |

CONE:

APPLICATION DETAILS:

NOTES:

| # | GLAZE | COATS |
|---|-------|-------|
| 1 | | |
| 2 | | |
| 3 | | |
| 4 | | |
| 5 | | |

CONE:

APPLICATION DETAILS:

NOTES:

| # | GLAZE | COATS |
|---|-------|-------|
| 1 | | |
| 2 | | |
| 3 | | |
| 4 | | |
| 5 | | |

CONE:

APPLICATION DETAILS:

NOTES:

| # | GLAZE | COATS |
|---|-------|-------|
| 1 | | |
| 2 | | |
| 3 | | |
| 4 | | |
| 5 | | |

CONE:

APPLICATION DETAILS:

NOTES:

GLAZE LAYERING

| # | GLAZE | COATS |
|---|-------|-------|
| 1 | | |
| 2 | | |
| 3 | | |
| 4 | | |
| 5 | | |

CONE:

APPLICATION DETAILS:

NOTES:

| # | GLAZE | COATS |
|---|-------|-------|
| 1 | | |
| 2 | | |
| 3 | | |
| 4 | | |
| 5 | | |

CONE:

APPLICATION DETAILS:

NOTES:

| # | GLAZE | COATS |
|---|-------|-------|
| 1 | | |
| 2 | | |
| 3 | | |
| 4 | | |
| 5 | | |

CONE:

APPLICATION DETAILS:

NOTES:

| # | GLAZE | COATS |
|---|-------|-------|
| 1 | | |
| 2 | | |
| 3 | | |
| 4 | | |
| 5 | | |

CONE:

APPLICATION DETAILS:

NOTES:

| # | GLAZE | COATS |
|---|-------|-------|
| 1 | | |
| 2 | | |
| 3 | | |
| 4 | | |
| 5 | | |

CONE:

APPLICATION DETAILS:

NOTES:

| # | GLAZE | COATS |
|---|-------|-------|
| 1 | | |
| 2 | | |
| 3 | | |
| 4 | | |
| 5 | | |

CONE:

APPLICATION DETAILS:

NOTES:

| # | GLAZE | COATS |
|---|-------|-------|
| 1 | | |
| 2 | | |
| 3 | | |
| 4 | | |
| 5 | | |

CONE:

APPLICATION DETAILS:

NOTES:

| # | GLAZE | COATS |
|---|-------|-------|
| 1 | | |
| 2 | | |
| 3 | | |
| 4 | | |
| 5 | | |

CONE:

APPLICATION DETAILS:

NOTES:

# GLAZE LAYERING

| # | GLAZE | COATS |
|---|-------|-------|
| 1 | | |
| 2 | | |
| 3 | | |
| 4 | | |
| 5 | | |

CONE:

APPLICATION DETAILS:

NOTES:

| # | GLAZE | COATS |
|---|-------|-------|
| 1 | | |
| 2 | | |
| 3 | | |
| 4 | | |
| 5 | | |

CONE:

APPLICATION DETAILS:

NOTES:

| # | GLAZE | COATS |
|---|-------|-------|
| 1 | | |
| 2 | | |
| 3 | | |
| 4 | | |
| 5 | | |

CONE:

APPLICATION DETAILS:

NOTES:

| # | GLAZE | COATS |
|---|-------|-------|
| 1 | | |
| 2 | | |
| 3 | | |
| 4 | | |
| 5 | | |

CONE:

APPLICATION DETAILS:

NOTES:

| # | GLAZE | COATS |
|---|-------|-------|
| 1 | | |
| 2 | | |
| 3 | | |
| 4 | | |
| 5 | | |

CONE:

APPLICATION DETAILS:

NOTES:

| # | GLAZE | COATS |
|---|-------|-------|
| 1 | | |
| 2 | | |
| 3 | | |
| 4 | | |
| 5 | | |

CONE:

APPLICATION DETAILS:

NOTES:

| # | GLAZE | COATS |
|---|-------|-------|
| 1 | | |
| 2 | | |
| 3 | | |
| 4 | | |
| 5 | | |

CONE:

APPLICATION DETAILS:

NOTES:

| # | GLAZE | COATS |
|---|-------|-------|
| 1 | | |
| 2 | | |
| 3 | | |
| 4 | | |
| 5 | | |

CONE:

APPLICATION DETAILS:

NOTES:

# BLEND CHART

## HOW TO GO FROM % RECIPE TO GRAM BATCH

CLEAR BLUE

|  |  | 2500G |
|---|---|---|
| GERSTLEY BORATE | 47% | 1211.3G |
| SILICA -------------- | 27% | 659.9G |
| EPK ----------------- | 20% | 515.5G |
| ALUMINA HYDRATE | 3% | 77.3G |
| ------- | ----- | ----- |
| COBALT ------------- | .5% | 12.9G |
| ------- | ----- | ----- |
| TOTAL -------------- | 97% | 2500G |

EQUATION -

$$\frac{\% \text{ PART}}{\% \text{ WHOLE}} \quad X \quad \frac{\text{BATCH PART}}{\text{BATCH WHOLE}}$$

EXAMPLE -

$$\frac{27\%}{97\%} \quad X \quad \frac{X \text{ GRAMS}}{2500 \text{ GRAMS}}$$

$$\frac{(27 \times 2500)}{97} = 695.9\text{G}$$

*NOTE: NOT ALL RECIPES ADD UP TO 100, AS IN THIS EXAMPLE. OFTEN THIS WAS DONE TO MAINTAIN WHOLE NUMBER % PARTS.

ALWAYS ADD UP THE BASE RECIPE (NOT INCLUDING THE COLORANTS) TO FIND THE % WHOLE.

## LINE BLEND

| A-100% | A-80% | A-60% | A-40% | A-20% | A-0% |
|---|---|---|---|---|---|
| B-0% | B-20% | B-40% | B-60% | B-80% | B-100% |

## TRIAXIAL BLEND

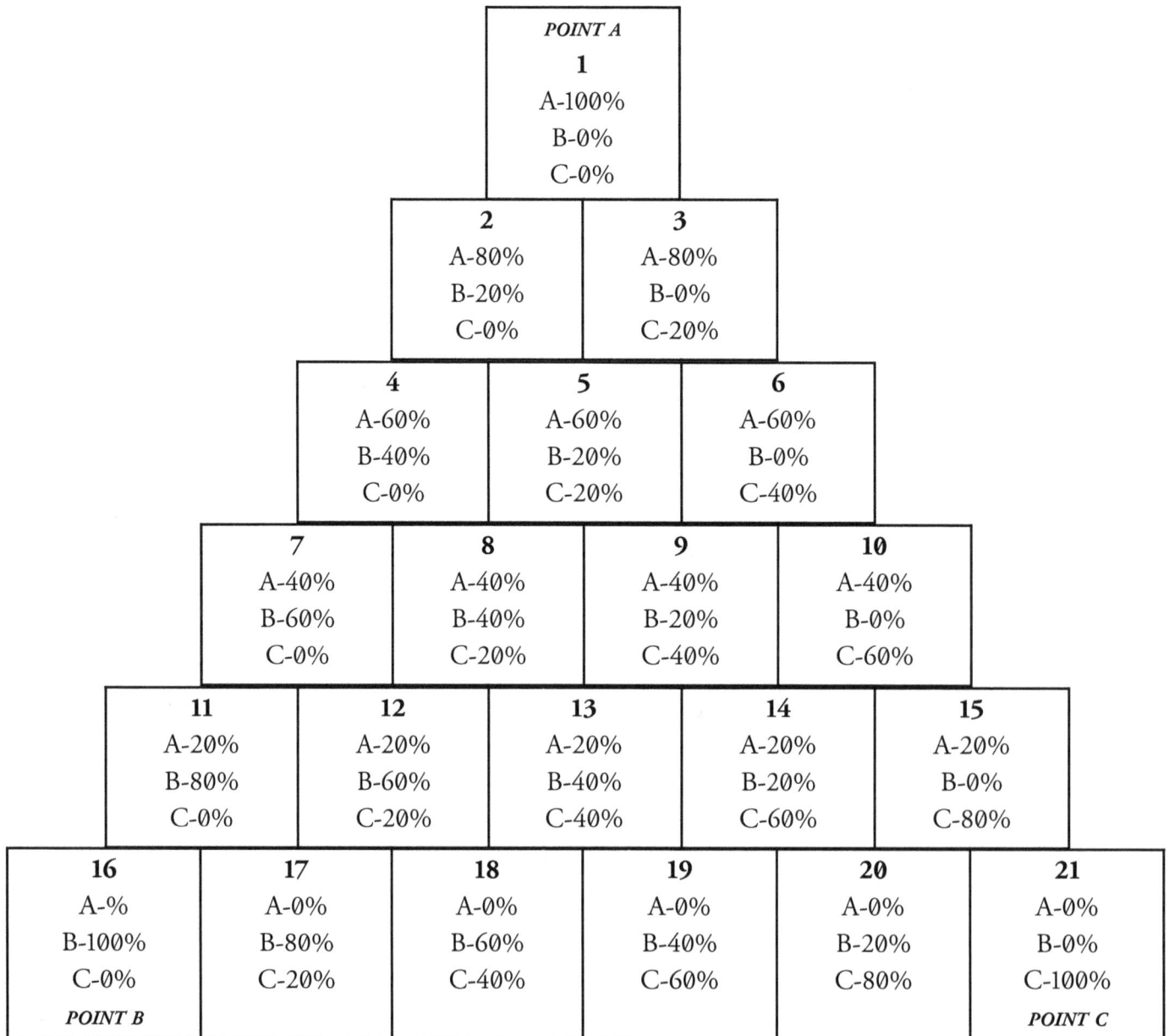

**POINT A**

**1**
A-100%
B-0%
C-0%

**2**
A-80%
B-20%
C-0%

**3**
A-80%
B-0%
C-20%

**4**
A-60%
B-40%
C-0%

**5**
A-60%
B-20%
C-20%

**6**
A-60%
B-0%
C-40%

**7**
A-40%
B-60%
C-0%

**8**
A-40%
B-40%
C-20%

**9**
A-40%
B-20%
C-40%

**10**
A-40%
B-0%
C-60%

**11**
A-20%
B-80%
C-0%

**12**
A-20%
B-60%
C-20%

**13**
A-20%
B-40%
C-40%

**14**
A-20%
B-20%
C-60%

**15**
A-20%
B-0%
C-80%

**16**
A-%
B-100%
C-0%
*POINT B*

**17**
A-0%
B-80%
C-20%

**18**
A-0%
B-60%
C-40%

**19**
A-0%
B-40%
C-60%

**20**
A-0%
B-20%
C-80%

**21**
A-0%
B-0%
C-100%
*POINT C*

# QUADRAXIAL BLEND

POINT A     POINT B

POINT C     POINT D

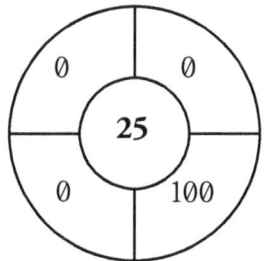

KEY

% GLAZE A          % GLAZE B

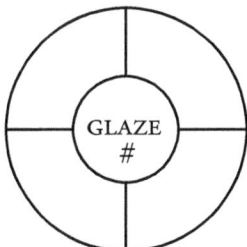

GLAZE
#

% GLAZE C          % GLAZE D

RECIPE AND 3X3 BLANK, 4X4 BLANK

### POINT A

| INGREDIENT | % | BATCH |
|---|---|---|
|  |  |  |
|  |  |  |
|  |  |  |
|  |  |  |
|  |  |  |
|  |  |  |
|  |  |  |
|  |  |  |
|  |  |  |
|  |  |  |
|  |  |  |
|  |  |  |
|  |  |  |
|  |  |  |
|  |  |  |

### POINT B

| INGREDIENT | % | BATCH |
|---|---|---|
|  |  |  |
|  |  |  |
|  |  |  |
|  |  |  |
|  |  |  |
|  |  |  |
|  |  |  |
|  |  |  |
|  |  |  |
|  |  |  |
|  |  |  |
|  |  |  |
|  |  |  |
|  |  |  |
|  |  |  |

### POINT C

| INGREDIENT | % | BATCH |
|---|---|---|
|  |  |  |
|  |  |  |
|  |  |  |
|  |  |  |
|  |  |  |
|  |  |  |
|  |  |  |
|  |  |  |
|  |  |  |
|  |  |  |
|  |  |  |
|  |  |  |
|  |  |  |
|  |  |  |
|  |  |  |

### POINT D

| INGREDIENT | % | BATCH |
|---|---|---|
|  |  |  |
|  |  |  |
|  |  |  |
|  |  |  |
|  |  |  |
|  |  |  |
|  |  |  |
|  |  |  |
|  |  |  |
|  |  |  |
|  |  |  |
|  |  |  |
|  |  |  |
|  |  |  |
|  |  |  |

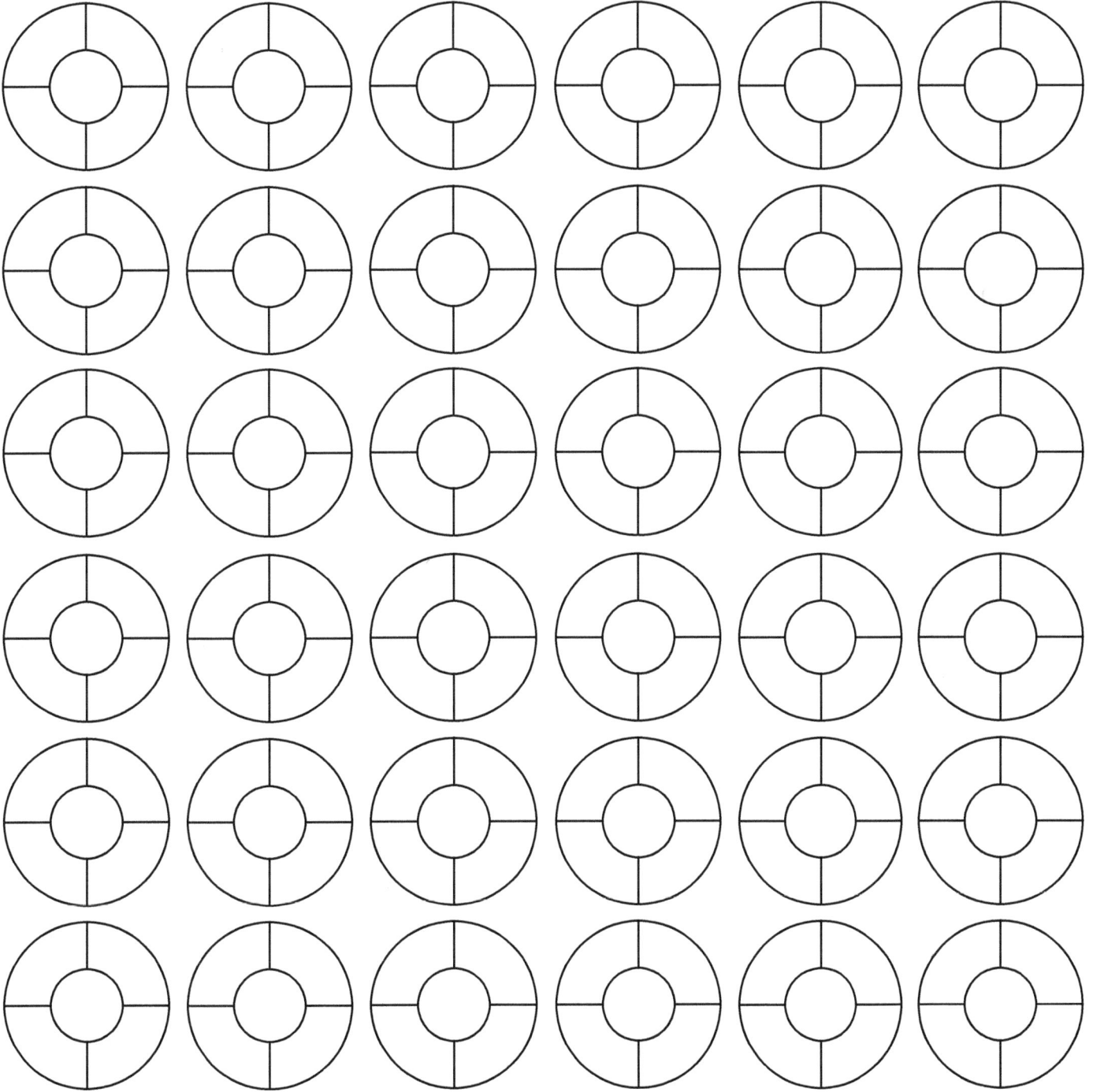

# SHOW SECTION

OBJECT IDEAS FOR POTTERS          "The useful and beautiful can have one voice." - Val Cushing

Kitchen

Baby and child dishes
Batter bowl
Berry bowl with catch bowl
Bowl
Bowls with handles
Cake stand
Canister
Casserole
Cream and sugar
Champagne chiller
Cheese board
Cheese dish
Cheese shaker
Chip and dip
Chopstick rest set
Coffee cup
Coffee pot
Colander
Commemorative plates
Condiment server
Cookie jar
Covered baking dishes
Covered mixing bowls
Covered pitcher
Cupcake stand
Cupcake/cake cover
Cutting board
Double walled cup or bowl
Double walled forms
Egg cup
Egg separator
Espresso cup
Ewer
French butter keeper
Fridge storage
Funnel
Garlic grater
Garlic keeper
Goblet/chalice
Graduated nesting bowls
Gravy boat
Honey pot

Insulated bottle
Jam jar
Lemon reamer
Limoncello glass
Locking jar
Martini glasses
Measuring spoons
Meat hammer
Milk jug
Mis en place bowls
Mortar and pestle
Mustard jar
Napkin holders
Napkin rings
Oil and vinegar cruet
Orange juicer
Pie pan
Pinch bowls
Pitcher
Plate
Platter
Pour overs
Punch bowl
Ramen bowl
Rice bowl
Ritual bowl
Rolling pin
Salt and pepper shakers
Salt pig
Serving basket
Shot glass
Silverware drainer
Slotted spoon
Soup bowl
Soup tureen
Special dishes for special foods
Spice jar
Spoonrest
Sugar bowl
Sushi set
Tagine
Tapas dishes
Tea bowl

Tea cup
Teacup with a strainer and lid
Teapot
Threaded vessel
Toast rack
Toroid bottle
Travel cup
Trivet
Tumbler
Vinegar bottle
Wine bottle
Wine decanter
Wine glass

Household

Address number sign
Ash tray
Aquarium decor
Beads
Bell
Bird bath
Bird feeder
Bonsai pot
Bookends
Bracelet
Bud vase
Buttons
Cabinet knob
Candelabra
Candle holder
Candle snuffer
Chandelier
Checker set
Chess set
Coaster set
Cookbook holder
Dice
Dominos
Door sign
Door stop
Earring
Earring holder
Essential oil burner
Furniture
Garden decor
Incense burner
Jacks
Knobs
Lamp base
Lamp shade
Lanturn
Mancala board
Mailbox
Match holder
Mirror frame
Oil lamp
Ornaments

Pegs for coat hook
Pendant
Pet dishes
Picture frame
Piggy bank
Plant marker
Plant pot
Plaque
Rain chain
Rattle
Religious objects
Ring
Ring dish
Rolling tray
Sign
Sink
Soap dish
Stash jars
Stocking holder
Sundial
Switch plate cover
Tie rack
Tiles
Tissue box cover
Toothbrush holder
Toothpick holder
Towel rack
Toys
Urn
Utensil holder
Utility jars for the home
Vase
Wall pocket
Wall sconce
Water pipe
Whistle
Wind chime
Yarn holder

# MARKET PACKING LIST

**Booth set up**
- O Tent
- O Tent stakes and weights
- O Tables and display materials
- O Table coverings
- O Directors chair
- O Cart/wagon/dolly
- O Signage
- O Boxes with work
- O Measuring tape
- O Tools for assembling
- O Lighting
- O Extension cords
- O Power strip
- O Generator
- O Inventory list
- O Museam wax
- O Sharpie
- O Masking tape
- O Price tags
- O Styling props

**Supply list**
- O Pens/markers
- O Notepad
- O Utility knife
- O Scissors
- O Hand wipes/sanitser
- O Trash bags
- O Duct tape

**Personal items**
- O Snacks
- O Water
- O First aid
- O Tissues
- O Jacket
- O Hat
- O Lip balm
- O Lotion
- O Medicine/tylenol
- O Sunscreen
- O Bug spray
- O Camera

- O Umbrella/raincoat
- O Lint roller
- O Fanny packSales
- O Credit card reader
- O Smart phone/charger
- O Backup battery
- O Internet/hotspot
- O Cash/change
- O Cash box
- O Packing materilas
- O Bubble wrap
- O Bag
- O Tape
- O Cling wrap
- O Rubber bands
- O Calculator
- O Recipt book

**Marketing products**
- O Buisness cards
- O Buisness card holder
- O Email sign-up sheet
- O Lables
- O Tablet or laptop

**Other**
- O
- O
- O
- O
- O
- O
- O
- O
- O
- O
- O
- O
- O

- O
- O
- O
- O
- O
- O
- O
- O
- O
- O
- O
- O
- O
- O
- O
- O
- O
- O
- O
- O
- O
- O
- O
- O
- O
- O
- O
- O
- O

# MARKET PACKING LIST

Your own list

○ ○ ○
○ ○ ○
○ ○ ○
○ ○ ○
○ ○ ○
○ ○ ○
○ ○ ○
○ ○ ○
○ ○ ○
○ ○ ○
○ ○ ○
○ ○ ○
○ ○ ○
○ ○ ○
○ ○ ○
○ ○ ○
○ ○ ○
○ ○ ○
○ ○ ○
○ ○ ○
○ ○ ○
○ ○ ○
○ ○ ○
○ ○ ○
○ ○ ○
○ ○ ○
○ ○ ○
○ ○ ○
○ ○ ○
○ ○ ○
○ ○ ○
○ ○ ○
○ ○ ○
○ ○ ○
○ ○ ○
○ ○ ○
○ ○ ○
○ ○ ○
○ ○ ○
○ ○ ○
○ ○ ○
○ ○ ○
○ ○ ○
○ ○ ○

APPLICATION TRACKER

| AP DUE DATE | SHOW TITLE | GALLERY | EXHIBITION DATE |
|---|---|---|---|
| | | | |
| | | | |
| | | | |
| | | | |
| | | | |
| | | | |
| | | | |
| | | | |
| | | | |
| | | | |
| | | | |
| | | | |
| | | | |
| | | | |
| | | | |
| | | | |
| | | | |
| | | | |
| | | | |
| | | | |
| | | | |
| | | | |
| | | | |
| | | | |
| | | | |
| | | | |
| | | | |
| | | | |
| | | | |
| | | | |
| | | | |
| | | | |
| | | | |
| | | | |

| P FEE | REQUIREMENTS | WEBSITE | NOTES |
|---|---|---|---|
| | | | |
| | | | |
| | | | |
| | | | |
| | | | |
| | | | |
| | | | |
| | | | |
| | | | |
| | | | |
| | | | |
| | | | |
| | | | |
| | | | |
| | | | |
| | | | |
| | | | |
| | | | |
| | | | |
| | | | |
| | | | |
| | | | |
| | | | |
| | | | |
| | | | |
| | | | |
| | | | |
| | | | |
| | | | |
| | | | |
| | | | |
| | | | |
| | | | |
| | | | |
| | | | |
| | | | |
| | | | |

APPLICATION TRACKER

| AP DUE DATE | SHOW TITLE | GALLERY | EXHIBITION DATE |
|---|---|---|---|
| | | | |
| | | | |
| | | | |
| | | | |
| | | | |
| | | | |
| | | | |
| | | | |
| | | | |
| | | | |
| | | | |
| | | | |
| | | | |
| | | | |
| | | | |
| | | | |
| | | | |
| | | | |
| | | | |
| | | | |
| | | | |
| | | | |
| | | | |
| | | | |
| | | | |
| | | | |
| | | | |
| | | | |
| | | | |
| | | | |
| | | | |
| | | | |
| | | | |
| | | | |

| P FEE | REQUIREMENTS | WEBSITE | NOTES |
|---|---|---|---|
| | | | |
| | | | |
| | | | |
| | | | |
| | | | |
| | | | |
| | | | |
| | | | |
| | | | |
| | | | |
| | | | |
| | | | |
| | | | |
| | | | |
| | | | |
| | | | |
| | | | |
| | | | |
| | | | |
| | | | |
| | | | |
| | | | |
| | | | |
| | | | |
| | | | |
| | | | |
| | | | |
| | | | |
| | | | |
| | | | |
| | | | |
| | | | |
| | | | |
| | | | |
| | | | |
| | | | |
| | | | |
| | | | |
| | | | |

# MARKET AND SHOW TRACKER

| DATES | MARKET/SHOW | CITY | AP FEE | BOOTH FEE | INVENTO |
|-------|-------------|------|--------|-----------|---------|
|       |             |      |        |           |         |
|       |             |      |        |           |         |
|       |             |      |        |           |         |
|       |             |      |        |           |         |
|       |             |      |        |           |         |
|       |             |      |        |           |         |
|       |             |      |        |           |         |
|       |             |      |        |           |         |
|       |             |      |        |           |         |
|       |             |      |        |           |         |
|       |             |      |        |           |         |
|       |             |      |        |           |         |
|       |             |      |        |           |         |
|       |             |      |        |           |         |
|       |             |      |        |           |         |
|       |             |      |        |           |         |
|       |             |      |        |           |         |
|       |             |      |        |           |         |
|       |             |      |        |           |         |
|       |             |      |        |           |         |
|       |             |      |        |           |         |
|       |             |      |        |           |         |
|       |             |      |        |           |         |
|       |             |      |        |           |         |
|       |             |      |        |           |         |
|       |             |      |        |           |         |
|       |             |      |        |           |         |
|       |             |      |        |           |         |
|       |             |      |        |           |         |
|       |             |      |        |           |         |
|       |             |      |        |           |         |
|       |             |      |        |           |         |

| RK SOLD | TOTAL SALES | NET PROFIT | NOTES |
| --- | --- | --- | --- |
|  |  |  |  |
|  |  |  |  |
|  |  |  |  |
|  |  |  |  |
|  |  |  |  |
|  |  |  |  |
|  |  |  |  |
|  |  |  |  |
|  |  |  |  |
|  |  |  |  |
|  |  |  |  |
|  |  |  |  |
|  |  |  |  |
|  |  |  |  |
|  |  |  |  |
|  |  |  |  |
|  |  |  |  |
|  |  |  |  |
|  |  |  |  |
|  |  |  |  |
|  |  |  |  |
|  |  |  |  |
|  |  |  |  |
|  |  |  |  |
|  |  |  |  |
|  |  |  |  |
|  |  |  |  |
|  |  |  |  |
|  |  |  |  |
|  |  |  |  |
|  |  |  |  |
|  |  |  |  |
|  |  |  |  |
|  |  |  |  |
|  |  |  |  |
|  |  |  |  |
|  |  |  |  |
|  |  |  |  |
|  |  |  |  |
|  |  |  |  |

# MARKET AND SHOW TRACKER

| DATES | MARKET/SHOW | CITY | AP FEE | BOOTH FEE | INVENTO |
|-------|-------------|------|--------|-----------|---------|
|       |             |      |        |           |         |
|       |             |      |        |           |         |
|       |             |      |        |           |         |
|       |             |      |        |           |         |
|       |             |      |        |           |         |
|       |             |      |        |           |         |
|       |             |      |        |           |         |
|       |             |      |        |           |         |
|       |             |      |        |           |         |
|       |             |      |        |           |         |
|       |             |      |        |           |         |
|       |             |      |        |           |         |
|       |             |      |        |           |         |
|       |             |      |        |           |         |
|       |             |      |        |           |         |
|       |             |      |        |           |         |
|       |             |      |        |           |         |
|       |             |      |        |           |         |
|       |             |      |        |           |         |
|       |             |      |        |           |         |
|       |             |      |        |           |         |
|       |             |      |        |           |         |
|       |             |      |        |           |         |
|       |             |      |        |           |         |
|       |             |      |        |           |         |
|       |             |      |        |           |         |
|       |             |      |        |           |         |
|       |             |      |        |           |         |
|       |             |      |        |           |         |
|       |             |      |        |           |         |
|       |             |      |        |           |         |
|       |             |      |        |           |         |
|       |             |      |        |           |         |
|       |             |      |        |           |         |
|       |             |      |        |           |         |
|       |             |      |        |           |         |
|       |             |      |        |           |         |
|       |             |      |        |           |         |
|       |             |      |        |           |         |

| RK SOLD | TOTAL SALES | NET PROFIT | NOTES |
|---|---|---|---|
| | | | |
| | | | |
| | | | |
| | | | |
| | | | |
| | | | |
| | | | |
| | | | |
| | | | |
| | | | |
| | | | |
| | | | |
| | | | |
| | | | |
| | | | |
| | | | |
| | | | |
| | | | |
| | | | |
| | | | |
| | | | |
| | | | |
| | | | |
| | | | |
| | | | |
| | | | |
| | | | |
| | | | |
| | | | |
| | | | |
| | | | |
| | | | |
| | | | |
| | | | |
| | | | |
| | | | |
| | | | |
| | | | |
| | | | |
| | | | |
| | | | |

# MARKET AND SHOW TRACKER

| DATES | MARKET/SHOW | CITY | AP FEE | BOOTH FEE | INVENTO |
|-------|-------------|------|--------|-----------|---------|
|       |             |      |        |           |         |
|       |             |      |        |           |         |
|       |             |      |        |           |         |
|       |             |      |        |           |         |
|       |             |      |        |           |         |
|       |             |      |        |           |         |
|       |             |      |        |           |         |
|       |             |      |        |           |         |
|       |             |      |        |           |         |
|       |             |      |        |           |         |
|       |             |      |        |           |         |
|       |             |      |        |           |         |
|       |             |      |        |           |         |
|       |             |      |        |           |         |
|       |             |      |        |           |         |
|       |             |      |        |           |         |
|       |             |      |        |           |         |
|       |             |      |        |           |         |
|       |             |      |        |           |         |
|       |             |      |        |           |         |
|       |             |      |        |           |         |
|       |             |      |        |           |         |
|       |             |      |        |           |         |
|       |             |      |        |           |         |
|       |             |      |        |           |         |
|       |             |      |        |           |         |
|       |             |      |        |           |         |
|       |             |      |        |           |         |
|       |             |      |        |           |         |
|       |             |      |        |           |         |
|       |             |      |        |           |         |
|       |             |      |        |           |         |

| RK SOLD | TOTAL SALES | NET PROFIT | NOTES |
|---|---|---|---|
| | | | |
| | | | |
| | | | |
| | | | |
| | | | |
| | | | |
| | | | |
| | | | |
| | | | |
| | | | |
| | | | |
| | | | |
| | | | |
| | | | |
| | | | |
| | | | |
| | | | |
| | | | |
| | | | |
| | | | |
| | | | |
| | | | |
| | | | |
| | | | |
| | | | |
| | | | |
| | | | |
| | | | |
| | | | |
| | | | |
| | | | |
| | | | |
| | | | |
| | | | |
| | | | |
| | | | |
| | | | |
| | | | |
| | | | |
| | | | |
| | | | |

SHOW INVENTORY

SHOW:                                    DATE:

| OBJECT | VARIATION | QUANTITY | PRICE | SKU |
|--------|-----------|----------|-------|-----|
|        |           |          |       |     |
|        |           |          |       |     |
|        |           |          |       |     |
|        |           |          |       |     |
|        |           |          |       |     |
|        |           |          |       |     |
|        |           |          |       |     |
|        |           |          |       |     |
|        |           |          |       |     |
|        |           |          |       |     |
|        |           |          |       |     |
|        |           |          |       |     |
|        |           |          |       |     |
|        |           |          |       |     |
|        |           |          |       |     |
|        |           |          |       |     |
|        |           |          |       |     |
|        |           |          |       |     |
|        |           |          |       |     |
|        |           |          |       |     |
|        |           |          |       |     |
|        |           |          |       |     |
|        |           |          |       |     |
|        |           |          |       |     |
|        |           |          |       |     |
|        |           |          |       |     |
|        |           |          |       |     |
|        |           |          |       |     |
|        |           |          |       |     |
|        |           |          |       |     |
|        |           |          |       |     |
|        |           |          |       |     |
|        |           |          |       |     |
|        |           |          |       |     |
|        |           |          |       |     |

SHOW:                              DATE:

| OBJECT | VARIATION | QUANTITY | PRICE | SKU |
|--------|-----------|----------|-------|-----|
|        |           |          |       |     |
|        |           |          |       |     |
|        |           |          |       |     |
|        |           |          |       |     |
|        |           |          |       |     |
|        |           |          |       |     |
|        |           |          |       |     |
|        |           |          |       |     |
|        |           |          |       |     |
|        |           |          |       |     |
|        |           |          |       |     |
|        |           |          |       |     |
|        |           |          |       |     |
|        |           |          |       |     |
|        |           |          |       |     |
|        |           |          |       |     |
|        |           |          |       |     |
|        |           |          |       |     |
|        |           |          |       |     |
|        |           |          |       |     |
|        |           |          |       |     |
|        |           |          |       |     |
|        |           |          |       |     |
|        |           |          |       |     |
|        |           |          |       |     |
|        |           |          |       |     |
|        |           |          |       |     |
|        |           |          |       |     |
|        |           |          |       |     |
|        |           |          |       |     |
|        |           |          |       |     |
|        |           |          |       |     |

SHOW INVENTORY

SHOW:                                    DATE:

| OBJECT | VARIATION | QUANTITY | PRICE | SKU |
|--------|-----------|----------|-------|-----|
|  |  |  |  |  |
|  |  |  |  |  |
|  |  |  |  |  |
|  |  |  |  |  |
|  |  |  |  |  |
|  |  |  |  |  |
|  |  |  |  |  |
|  |  |  |  |  |
|  |  |  |  |  |
|  |  |  |  |  |
|  |  |  |  |  |
|  |  |  |  |  |
|  |  |  |  |  |
|  |  |  |  |  |
|  |  |  |  |  |
|  |  |  |  |  |
|  |  |  |  |  |
|  |  |  |  |  |
|  |  |  |  |  |
|  |  |  |  |  |
|  |  |  |  |  |
|  |  |  |  |  |
|  |  |  |  |  |
|  |  |  |  |  |
|  |  |  |  |  |
|  |  |  |  |  |
|  |  |  |  |  |
|  |  |  |  |  |
|  |  |  |  |  |
|  |  |  |  |  |
|  |  |  |  |  |
|  |  |  |  |  |
|  |  |  |  |  |

SHOW:                              DATE:

| OBJECT | VARIATION | QUANTITY | PRICE | SKU |
|---|---|---|---|---|
|  |  |  |  |  |
|  |  |  |  |  |
|  |  |  |  |  |
|  |  |  |  |  |
|  |  |  |  |  |
|  |  |  |  |  |
|  |  |  |  |  |
|  |  |  |  |  |
|  |  |  |  |  |
|  |  |  |  |  |
|  |  |  |  |  |
|  |  |  |  |  |
|  |  |  |  |  |
|  |  |  |  |  |
|  |  |  |  |  |
|  |  |  |  |  |
|  |  |  |  |  |
|  |  |  |  |  |
|  |  |  |  |  |
|  |  |  |  |  |
|  |  |  |  |  |
|  |  |  |  |  |
|  |  |  |  |  |
|  |  |  |  |  |
|  |  |  |  |  |
|  |  |  |  |  |
|  |  |  |  |  |
|  |  |  |  |  |
|  |  |  |  |  |
|  |  |  |  |  |
|  |  |  |  |  |
|  |  |  |  |  |
|  |  |  |  |  |
|  |  |  |  |  |
|  |  |  |  |  |
|  |  |  |  |  |

SHOW INVENTORY

SHOW:                                    DATE:

| OBJECT | VARIATION | QUANTITY | PRICE | SKU |
|--------|-----------|----------|-------|-----|
|        |           |          |       |     |
|        |           |          |       |     |
|        |           |          |       |     |
|        |           |          |       |     |
|        |           |          |       |     |
|        |           |          |       |     |
|        |           |          |       |     |
|        |           |          |       |     |
|        |           |          |       |     |
|        |           |          |       |     |
|        |           |          |       |     |
|        |           |          |       |     |
|        |           |          |       |     |
|        |           |          |       |     |
|        |           |          |       |     |
|        |           |          |       |     |
|        |           |          |       |     |
|        |           |          |       |     |
|        |           |          |       |     |
|        |           |          |       |     |
|        |           |          |       |     |
|        |           |          |       |     |
|        |           |          |       |     |
|        |           |          |       |     |
|        |           |          |       |     |
|        |           |          |       |     |
|        |           |          |       |     |
|        |           |          |       |     |
|        |           |          |       |     |
|        |           |          |       |     |
|        |           |          |       |     |
|        |           |          |       |     |
|        |           |          |       |     |
|        |           |          |       |     |

SHOW:                                    DATE:

| OBJECT | VARIATION | QUANTITY | PRICE | SKU |
|--------|-----------|----------|-------|-----|
|  |  |  |  |  |
|  |  |  |  |  |
|  |  |  |  |  |
|  |  |  |  |  |
|  |  |  |  |  |
|  |  |  |  |  |
|  |  |  |  |  |
|  |  |  |  |  |
|  |  |  |  |  |
|  |  |  |  |  |
|  |  |  |  |  |
|  |  |  |  |  |
|  |  |  |  |  |
|  |  |  |  |  |
|  |  |  |  |  |
|  |  |  |  |  |
|  |  |  |  |  |
|  |  |  |  |  |
|  |  |  |  |  |
|  |  |  |  |  |
|  |  |  |  |  |
|  |  |  |  |  |
|  |  |  |  |  |
|  |  |  |  |  |
|  |  |  |  |  |
|  |  |  |  |  |
|  |  |  |  |  |
|  |  |  |  |  |
|  |  |  |  |  |
|  |  |  |  |  |
|  |  |  |  |  |
|  |  |  |  |  |
|  |  |  |  |  |
|  |  |  |  |  |
|  |  |  |  |  |
|  |  |  |  |  |
|  |  |  |  |  |
|  |  |  |  |  |

SHOW INVENTORY

SHOW:                                    DATE:

| OBJECT | VARIATION | QUANTITY | PRICE | SKU |
|--------|-----------|----------|-------|-----|
|        |           |          |       |     |
|        |           |          |       |     |
|        |           |          |       |     |
|        |           |          |       |     |
|        |           |          |       |     |
|        |           |          |       |     |
|        |           |          |       |     |
|        |           |          |       |     |
|        |           |          |       |     |
|        |           |          |       |     |
|        |           |          |       |     |
|        |           |          |       |     |
|        |           |          |       |     |
|        |           |          |       |     |
|        |           |          |       |     |
|        |           |          |       |     |
|        |           |          |       |     |
|        |           |          |       |     |
|        |           |          |       |     |
|        |           |          |       |     |
|        |           |          |       |     |
|        |           |          |       |     |
|        |           |          |       |     |
|        |           |          |       |     |
|        |           |          |       |     |
|        |           |          |       |     |
|        |           |          |       |     |
|        |           |          |       |     |
|        |           |          |       |     |
|        |           |          |       |     |
|        |           |          |       |     |
|        |           |          |       |     |
|        |           |          |       |     |
|        |           |          |       |     |

SHOW:                           DATE:

| OBJECT | VARIATION | QUANTITY | PRICE | SKU |
|---|---|---|---|---|
| | | | | |
| | | | | |
| | | | | |
| | | | | |
| | | | | |
| | | | | |
| | | | | |
| | | | | |
| | | | | |
| | | | | |
| | | | | |
| | | | | |
| | | | | |
| | | | | |
| | | | | |
| | | | | |
| | | | | |
| | | | | |
| | | | | |
| | | | | |
| | | | | |
| | | | | |
| | | | | |
| | | | | |
| | | | | |
| | | | | |
| | | | | |
| | | | | |
| | | | | |
| | | | | |
| | | | | |
| | | | | |

# SHOW INVENTORY

SHOW:                                    DATE:

| OBJECT | VARIATION | QUANTITY | PRICE | SKU |
|--------|-----------|----------|-------|-----|
|        |           |          |       |     |
|        |           |          |       |     |
|        |           |          |       |     |
|        |           |          |       |     |
|        |           |          |       |     |
|        |           |          |       |     |
|        |           |          |       |     |
|        |           |          |       |     |
|        |           |          |       |     |
|        |           |          |       |     |
|        |           |          |       |     |
|        |           |          |       |     |
|        |           |          |       |     |
|        |           |          |       |     |
|        |           |          |       |     |
|        |           |          |       |     |
|        |           |          |       |     |
|        |           |          |       |     |
|        |           |          |       |     |
|        |           |          |       |     |
|        |           |          |       |     |
|        |           |          |       |     |
|        |           |          |       |     |
|        |           |          |       |     |
|        |           |          |       |     |
|        |           |          |       |     |
|        |           |          |       |     |
|        |           |          |       |     |
|        |           |          |       |     |
|        |           |          |       |     |
|        |           |          |       |     |
|        |           |          |       |     |
|        |           |          |       |     |
|        |           |          |       |     |
|        |           |          |       |     |

SHOW:                                    DATE:

| OBJECT | VARIATION | QUANTITY | PRICE | SKU |
|--------|-----------|----------|-------|-----|
|  |  |  |  |  |
|  |  |  |  |  |
|  |  |  |  |  |
|  |  |  |  |  |
|  |  |  |  |  |
|  |  |  |  |  |
|  |  |  |  |  |
|  |  |  |  |  |
|  |  |  |  |  |
|  |  |  |  |  |
|  |  |  |  |  |
|  |  |  |  |  |
|  |  |  |  |  |
|  |  |  |  |  |
|  |  |  |  |  |
|  |  |  |  |  |
|  |  |  |  |  |
|  |  |  |  |  |
|  |  |  |  |  |
|  |  |  |  |  |
|  |  |  |  |  |
|  |  |  |  |  |
|  |  |  |  |  |
|  |  |  |  |  |
|  |  |  |  |  |
|  |  |  |  |  |
|  |  |  |  |  |
|  |  |  |  |  |
|  |  |  |  |  |
|  |  |  |  |  |
|  |  |  |  |  |
|  |  |  |  |  |
|  |  |  |  |  |
|  |  |  |  |  |
|  |  |  |  |  |

SHOW INVENTORY

SHOW:                                         DATE:

| OBJECT | VARIATION | QUANTITY | PRICE | SKU |
|--------|-----------|----------|-------|-----|
|        |           |          |       |     |
|        |           |          |       |     |
|        |           |          |       |     |
|        |           |          |       |     |
|        |           |          |       |     |
|        |           |          |       |     |
|        |           |          |       |     |
|        |           |          |       |     |
|        |           |          |       |     |
|        |           |          |       |     |
|        |           |          |       |     |
|        |           |          |       |     |
|        |           |          |       |     |
|        |           |          |       |     |
|        |           |          |       |     |
|        |           |          |       |     |
|        |           |          |       |     |
|        |           |          |       |     |
|        |           |          |       |     |
|        |           |          |       |     |
|        |           |          |       |     |
|        |           |          |       |     |
|        |           |          |       |     |
|        |           |          |       |     |
|        |           |          |       |     |
|        |           |          |       |     |
|        |           |          |       |     |
|        |           |          |       |     |
|        |           |          |       |     |
|        |           |          |       |     |
|        |           |          |       |     |
|        |           |          |       |     |
|        |           |          |       |     |
|        |           |          |       |     |

SHOW:                                    DATE:

| OBJECT | VARIATION | QUANTITY | PRICE | SKU |
|--------|-----------|----------|-------|-----|
|        |           |          |       |     |
|        |           |          |       |     |
|        |           |          |       |     |
|        |           |          |       |     |
|        |           |          |       |     |
|        |           |          |       |     |
|        |           |          |       |     |
|        |           |          |       |     |
|        |           |          |       |     |
|        |           |          |       |     |
|        |           |          |       |     |
|        |           |          |       |     |
|        |           |          |       |     |
|        |           |          |       |     |
|        |           |          |       |     |
|        |           |          |       |     |
|        |           |          |       |     |
|        |           |          |       |     |
|        |           |          |       |     |
|        |           |          |       |     |
|        |           |          |       |     |
|        |           |          |       |     |
|        |           |          |       |     |
|        |           |          |       |     |
|        |           |          |       |     |
|        |           |          |       |     |
|        |           |          |       |     |
|        |           |          |       |     |
|        |           |          |       |     |
|        |           |          |       |     |
|        |           |          |       |     |
|        |           |          |       |     |
|        |           |          |       |     |
|        |           |          |       |     |

SHOW INVENTORY

SHOW:                                    DATE:

| OBJECT | VARIATION | QUANTITY | PRICE | SKU |
|--------|-----------|----------|-------|-----|
|  |  |  |  |  |
|  |  |  |  |  |
|  |  |  |  |  |
|  |  |  |  |  |
|  |  |  |  |  |
|  |  |  |  |  |
|  |  |  |  |  |
|  |  |  |  |  |
|  |  |  |  |  |
|  |  |  |  |  |
|  |  |  |  |  |
|  |  |  |  |  |
|  |  |  |  |  |
|  |  |  |  |  |
|  |  |  |  |  |
|  |  |  |  |  |
|  |  |  |  |  |
|  |  |  |  |  |
|  |  |  |  |  |
|  |  |  |  |  |
|  |  |  |  |  |
|  |  |  |  |  |
|  |  |  |  |  |
|  |  |  |  |  |
|  |  |  |  |  |
|  |  |  |  |  |
|  |  |  |  |  |
|  |  |  |  |  |
|  |  |  |  |  |
|  |  |  |  |  |
|  |  |  |  |  |
|  |  |  |  |  |

SHOW:                                 DATE:

| OBJECT | VARIATION | QUANTITY | PRICE | SKU |
|--------|-----------|----------|-------|-----|
|  |  |  |  |  |
|  |  |  |  |  |
|  |  |  |  |  |
|  |  |  |  |  |
|  |  |  |  |  |
|  |  |  |  |  |
|  |  |  |  |  |
|  |  |  |  |  |
|  |  |  |  |  |
|  |  |  |  |  |
|  |  |  |  |  |
|  |  |  |  |  |
|  |  |  |  |  |
|  |  |  |  |  |
|  |  |  |  |  |
|  |  |  |  |  |
|  |  |  |  |  |
|  |  |  |  |  |
|  |  |  |  |  |
|  |  |  |  |  |
|  |  |  |  |  |
|  |  |  |  |  |
|  |  |  |  |  |
|  |  |  |  |  |
|  |  |  |  |  |
|  |  |  |  |  |
|  |  |  |  |  |
|  |  |  |  |  |
|  |  |  |  |  |
|  |  |  |  |  |
|  |  |  |  |  |
|  |  |  |  |  |
|  |  |  |  |  |
|  |  |  |  |  |
|  |  |  |  |  |
|  |  |  |  |  |

OBJECT STEPS

OBJECT:                                    STEPS:

CLAY:

TEMP:

TOOLS:

OBJECT:                                    STEPS:

CLAY:

TEMP:

TOOLS:

OBJECT:                    STEPS:

CLAY:

TEMP:

TOOLS:

OBJECT:                    STEPS:

CLAY:

TEMP:

TOOLS:

OBJECT:                    STEPS:

CLAY:

TEMP:

TOOLS:

OBJECT:                    STEPS:

CLAY:

TEMP:

TOOLS:

OBJECT:                         STEPS:

CLAY:

TEMP:

TOOLS:

OBJECT:                         STEPS:

CLAY:

TEMP:

TOOLS:

OBJECT STEPS

OBJECT:                    STEPS:

CLAY:

TEMP:

TOOLS:

OBJECT:                    STEPS:

CLAY:

TEMP:

TOOLS:

OBJECT:                            STEPS:

CLAY:

TEMP:

TOOLS:

OBJECT:                            STEPS:

CLAY:

TEMP:

TOOLS:

# OBJECT STEPS

OBJECT:                                  STEPS:

CLAY:

TEMP:

TOOLS:

OBJECT:                                  STEPS:

CLAY:

TEMP:

TOOLS:

OBJECT:                 STEPS:

CLAY:

TEMP:

TOOLS:

OBJECT:                 STEPS:

CLAY:

TEMP:

TOOLS:

OBJECT:                    STEPS:

CLAY:

TEMP:

TOOLS:

OBJECT:                    STEPS:

CLAY:

TEMP:

TOOLS:

www.ingramcontent.com/pod-product-compliance
Lightning Source LLC
Chambersburg PA
CBHW061306310326
41914CB00112B/1454